The Gothic: A Very Short Introduction

VERY SHORT INTRODUCTIONS are for anyone wanting a stimulating and accessible way into a new subject. They are written by experts, and have been translated into more than 45 different languages.

The series began in 1995, and now covers a wide variety of topics in every discipline. The VSI library now contains over 500 volumes—a Very Short Introduction to everything from Psychology and Philosophy of Science to American History and Relativity—and continues to grow in every subject area.

Titles in the series include the following:

Nick Groom

THE GOTHIC

A Very Short Introduction

OXFORD
UNIVERSITY PRESS

OXFORD

UNIVERSITY PRESS

Great Clarendon Street, Oxford, OX2 6DP,
United Kingdom

Oxford University Press is a department of the University of Oxford.
It furthers the University's objective of excellence in research, scholarship,
and education by publishing worldwide. Oxford is a registered trade mark of
Oxford University Press in the UK and in certain other countries

British Library Cataloguing in Publication Data

Data available

Library of Congress Cataloging in Publication Data

Data available

ISBN 978-0-19-958679-0
Printed and bound by
CPI Group (UK) Ltd, Croydon, CR0 4YY

To Joanne
'forever remain'

Contents

The Gothic

Preface: a history of the Gothic in thirteen chapters

Type 'Gothic' into Google and you get over 250 million hits: images of ecclesiastical architecture, websites devoted to 'bone-chilling' literature, and opportunities to purchase alternative footwear. Open a book on 'The Gothic' and you are likely to see chapters on 'Excess', 'Transgression', and 'Diffusion'. Trying to identify the original 'Goths', meanwhile, can lead either to an ancient barbarian race or to a rock music subculture of the 1980s.

All these things are indeed Gothic, and by tracing the meanings and associations the word 'Gothic' had at different times and in different contexts, this book will argue that they are part of a common history and occasionally share common features. Hence the following chapters will investigate classical history, mediaeval architecture, seventeenth-century politics, eighteenth- and nineteenth-century literature, and twentieth- and twenty-first-century film and music. It is only through such an evolutionary analysis that the Gothic as a whole makes sense, and so, by thoroughly historicizing the meanings of 'Gothic', we can begin to assess its relevance today.

Consequently, this book differs from earlier accounts of the Goths and the Gothic. Histories of literary Gothic, for example, usually

begin in 1764 with the publication of Horace Walpole's *Castle of Otranto* and ignore the rich semantic history of the term in the centuries preceding Walpole's novel. But the Gothic was not simply a reaction to the Enlightenment, and the rise of the Gothic novel is part of a far longer history that continues to the present with no sign of abating. Similarly, studies of the contemporary Goth scene tend to focus on the influence of films, television, music, and fashion on lifestyle and values but give no sense of the history and prehistory of the Gothic—the deeper cultural sources and social implications of the term, which add significant nuances to its current usage and which may help to explain the variety and diversity of contemporary activity.

The restlessness of the Gothic tradition (if it can be called that) can only be partly tamed, and this book is by no means an attempt to synthesize all the meanings of 'Gothic' into one coherent whole. Neither should it be assumed that those who have used the word in the past, or who currently use it today, are likely to be aware of the complexity and contradictions of the term—it is clearly not necessary to be an expert in the history of late antiquity to qualify as a guitarist in a modern Goth band. What this book will, I hope, demonstrate is that the Gothic has an ongoing history, and that this history shows that the word and its associations have been frequently contested, disputed, and redefined. There is much at stake in the meaning of 'Gothic': the following story reveals the prevailing attitudes of the times in which the Gothic has been most influential, and why it remains with us to this day.

Times past

If many introductions to the Gothic distort the word, stretching it into an umbrella term for transgression, marginality, and 'otherness', this is because much contemporary critical theory is effectively Gothic writing itself. The psychoanalytic case-studies of Sigmund Freud are a fine early example of this tendency, sharing many of the established features of nineteenth-century Gothic

literature that themselves had a venerable ancestry—a fascination with dreams and ghosts, guilt and shame, dismemberment and death. This in turn encouraged twentieth-century commentators to enlist the Gothic in everything from theorizing social taboos to analysing sexual politics. The result is that the Gothic now risks being emptied or nullified as a meaningful term—indeed, one critic has claimed that 'In the twentieth century Gothic is everywhere and nowhere'. What has really happened is that various critical theorists have fixated on certain sensational aspects of the Gothic such as the workings of the unconscious and subconscious, the influence of unseen agencies, and trespass, abjection, sacrifice, and extinction. Michel Foucault, for example, wrote at length on the manipulation of the body by institutional power relations through discourses of illness, madness, incarceration, and sexual deviancy. Jacques Derrida, meanwhile, proposed a theory of 'hauntology' (or ghostliness) by treating Marx and Engels' *Communist Manifesto* as a Gothic text—it famously begins 'A spectre is haunting Europe'. Yet despite this, these theorists have not acknowledged the cultural history of the Gothic, nor how they are implicated in it themselves. Like other accounts of the Gothic confined to one discipline or to one historical period, they are doomed to be at best severely limited, at worst a grotesque distortion.

The bones I have disturbed and the ghosts I will raise in the following pages are not the instruments of critical theory: they are the manifestations of nearly two thousand years of cultural fears....

Acknowledgements

The idea for this essay on the Gothic first came about in lengthy conversations with Chris Brooks while he was writing his seminal study *The Gothic Revival*, and I am grateful to Andrea Keegan of Oxford University Press for giving me the opportunity—some years later—to write the present book; my only regret is that Chris is not alive to see it. I am indebted to colleagues at the University of Exeter who have supported me in this project and responded generously to work-in-progress, and to library staff at both the Tremough and Streatham campuses, in particular the Special Collections librarians. I would also like to thank the students on my BA option 'The Gothic' and in various MA seminars who have discussed, challenged, and contributed to these ideas. The anonymous readers who reviewed the proposal and draft for OUP offered much constructive criticism and helped to shape the text. Christopher Gill, Ande Tucker, and Paul Walker answered queries promptly, and contemporary online contacts and communities provided welcome assistance (notably The Watchman and New Gold Dawn). My most profound thanks, however, are to my wife Joanne. It is to her, my tower of strength, that I dedicate this work. Thank you.

List of illustrations

Chapter 1
Origins of the Goths

The story begins with the barbarians—a vast and varied group of many peoples. The word 'barbarian' itself reveals how much is covered by the term. It is derived from the Greek βάρβαρος and probably derived onomatopoeically (to Hellenic ears) from the harsh-sounding 'baa-baa'-isms of their speech. 'Barbarous' meant foreign—that is, non-Hellenic—and so came to mean outlandish, rude, or brutal. The Romans extended this meaning to all peoples who were neither Latin nor Greek, before encompassing all those outside the Roman Empire. The word was a catch-all for the uncivilized and uncultured, and with the conversion of the Empire to Christianity it was applied to any non-Christians.

Hence the barbarians occupied all the lands beyond the borders of the empire. According to Pliny the Elder (AD75), the barbarian tribes were multitudinous: Vandals (that is, Burgundians, *Varini*, *Charini*, and *Gutones*), *Ingvaeones* (*Cimbri*, *Teutones*, and *Chauci*), *Isthaeones* (probably the *Sicambri*), *Herminones* (*Suebi*, *Hermanduri*, *Chatti*, and *Cherusci*), and the *Peucini* (or *Bastarnae*). The impression given by such fanciful categorizations was of the confusion and chaos that lay outside the order of civilization. But there was no mention of the Goths.

A generation after Pliny, the Roman historian Tacitus described in greater detail the peoples north of the Empire. In *Germania* (AD98) Tacitus defined these non-Roman peoples genealogically, deriving them from a common ancestor, and remarking on the purity of their barbarian pedigree. Tacitus described the *Germani*, who inhabited a land of forests and swamps and lived in individual dwellings, with some admiration. Their democratic governance, their hunger for military renown and sense of honour, their oral tradition of heroic song, and their hospitality and virtuous monogamy was in stark comparison not only to other barbarian tribes, but also with the increasingly decadent immorality of the Romans. It was an image of savage pastoralism that would prove compelling to later historians and historiographers. But although Tacitus mentions over forty Germanic tribes in *Germania*, there is no mention of the Goths.

At about the same time that Tacitus was writing, the Romano-Jewish historian Josephus was developing the Rabbinical tradition of the northern peoples. In *Genesis* 10.2, Magog is named as one of the sons of Japheth, who is linked with northern hegemony and fair-haired races. Synthesizing Biblical and Hellenic history, Josephus describes the Scythians (first noted by the Greek historian Herodotus) as descended from Magog. But again there is no clear mention of the Goths.

The confidence with which historians in the past have identified the Goths, then, appears to be misplaced. Gothic origins in Scythia (modern Romania and southern Russia) suggest that 'Goth' was a new name for old barbarians. The Goths emerged only gradually from the profuse backdrop of barbarian tribes, appearing as auxiliaries serving in the Roman army in the early third century AD. They first ventured into Roman territory in the year 238, sacking Histria at the mouth of the Danube, subsequently skirmished with the Imperial legions in Dacia (now Transylvania, the Carpathian mountains, and the lower Danube), and regularly launched maritime raids from bases on the Black Sea. They won

Dacian land in 271, and so for a century Gothic territory ran from the Pannonian basin down the Danube to its delta (modern Hungary, Romania, with parts of Vojvodina and Slovakia). By this time they had split into *Tervingi* (or *Theruingi*: forest people) and *Greutingi* (or *Greuthungi*: shore people). The Latin names for the tribes of the *Tervingi* and *Greutingi* were later replaced by the names Visigoths and Ostrogoths, respectively—literally, Western Goths and Eastern Goths.

By the fourth century the Goths commanded much of what are now the southern post-Soviet states, the River Danube creating a natural boundary to the north-east edge of the Roman Empire and Western civilization. During these years of relative peace Christianity spread among the Goths, a Gothic bishop attended the Council of Nicaea, and missions were launched. The most renowned Gothic cleric was Ulfila, consecrated as a bishop in 341. Ulfila devised a Gothic alphabet by adapting two Greek systems supplemented by Latin and Runic, in order to translate the New Testament. The Goths were therefore the first of the barbarians to develop a literate culture.

First blood

The historical Goths first come into sharp focus in the writings of the Roman historian Ammianus Marcellinus, whose surviving chronicle covers the years 353–78, Ammianus' own lifetime. This account describes the arrival of the Huns from the east, a migration that impelled the Goths to increase their incursions into the Roman Empire. Later archaeological finds in the Ukraine and Transylvania (known as the Sîntana de Mureş-Černjachov culture) confirm that Gothic tribes settled along river valleys, establishing large, unwooded inhabitations that were reasonably densely populated. The people were agricultural and sedentary, subsisting on cereal crops and animal husbandry. Their cemeteries and grave goods favoured pottery over weapons, and they wrote in a runic alphabet. The martyrdom of St Saba (12 April 372) adds further

possible detail to this picture. Saba's pious refusal to eat meat sacrificed to pagan gods is set against a background of clan society, communal feasting, and a village council that appears to parallel the 'national' council described in Tacitus' *Germania*.

In 374–5 the Huns attacked and defeated the multi-ethnic Greuthungian kingdom of the Ukraine, causing the king of the Goths, Ermanaric (Ermenrichus), to commit suicide. Goths are next heard of serving in Attila's army—indeed, there was a degree of interdependence between Goths and Huns. The Goths provided the Huns with both agricultural staples and infantrymen, and there even seems to have been some cross-cultural influence: the strange Hunnish practice of elongating the skull through infant cranial deformation had adherents among the Ostrogoths, and the later Germanic tradition of epic poetry incorporates Attila as a heroic character.

The barbarian peoples massed on the banks of the Danube as the Gothic territories were occupied, and in 376 and by consent of the Emperor Valens a huge number of the Theruingi crossed the vast river—it was swollen by seasonal rains and nearly two miles across. Ammianus quotes Virgil in estimating how many landed on the Roman banks:

> Who wishes to know this would wish to know
> How many grains of sand on the Libyan plain
> By Zephyrus are swept.

According to the historian, the Empire had brought the seeds of destruction across its own borders.

Romano-Gothic relations were tense and soon exploded into open conflict. The ensuing war was described by the poet Claudian (fl. 395–404), who describes the Goths as supernatural, a threat emerging in dreams and ill omens, accompanied by 'showers of stones, bees swarming in strange places, furious fires destroying

houses from no known cause, a comet', and constant eclipses of
the moon:

> Men would not believe that the moon had been defrauded of her
> brother the sun, forbidden to give light by the interposition of the
> earth; they thought that Thessalian witches, accompanying the
> barbarian armies, were darkening her rays with their country's
> magic spells.

The Goths seized the Roman imagination like avatars of
nightmare. The Romans were comprehensively defeated and
the Emperor Valens fell in battle; his body was never recovered.

Visigoths

The Romans now attempted to contain the *Theruingi* (Visigoths)
with federal treaties, but their new leader Alaric rebelled in 395
and led them through Greece, where they seized power. In 401,
Alaric marched on Italy. He took Venetia, and then Milan, and by
408 he was in the Po valley. Rome was exposed—the city had little
defence and was suffering a famine. Alaric's sack began on 24
August 410, and lasted three days.

It was a devastating event. The sack inspired Augustine to write
De civitate Dei (*Concerning the City of God*) and Orosius his
Historia—both works of consolation which energetically argued
against anti-Christian polemic that interpreted the sack of Rome
as the revenge of the pagan gods on the conversion of the Empire.
Consequently, Orosius depicts the marauding Goths as Christian
missionaries, pausing in their pillage to worship God and his
company of saints, and so in their work effectively bringing about
the salvation of Rome. Orosius also identified the Goths with the
classical *Getae*, who originated in Scythia. He therefore gave the
Goths a history and heritage and an independence from Rome,
thereby challenging the identification of Scythia as the
conventional axis of barbarian hostility against the Empire. It was

an account that would prove to be highly influential on subsequent historians.

Alaric's brother-in-law, Athaulf, then took the Visigoths into Gaul and settled in Aquitaine, before marrying the sister of the Emperor, who had been taken hostage. Despite the assassination of Athaulf the situation was eventually stabilized by forming the Visigothic 'Kingdom of Toulouse' in southern Gaul in 418—effectively an independent state within the Empire, loyal to Rome. By the time the Visigoths declared independence from Rome in 475, their settlements in Spain constituted the largest political body in western Europe: excepting Galicia and the Basque mountains, the Visigothic kingdom reached from the south bank of the Loire to Gibraltar. It survived as the Kingdom of Toledo until the Islamic Berber invasion of 711.

Ostrogoths

The Ostrogoths, meanwhile, consisted of two groups: one remaining in Pannonia with the Huns, the other in the Balkans as part of the Roman Empire (see Figure 1). The Pannonian Goths marched with Attila through Roman Empire until the collapse of the Hunnic invasion in 454, while the Thracian Goths served in the Roman Byzantine army. These factions were united by the Pannonian leader Theoderic the Amal (later known as Theoderic the Great) who was then invited by the Emperor Zeno to defeat Odoacer, a Roman officer and barbarian leader who had assumed rule of Italy. Odoacer made a counter-proposal that he and Theodoric rule Italy together, to which Theodoric agreed—but at the ensuing reconciliation feast, he had Odoacer and his family killed. Theodoric thenceforth ruled Italy as Zeno's regent. The Goths had military supremacy, the Romans had civic structures and social infrastructures: it was an unlikely union held together by the force of Theodoric's personality and it inspired a thriving barbarian intellectual culture led by Ennodius, Cassiodorus, and Boethius.

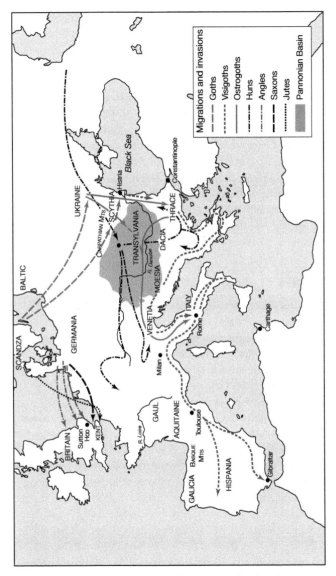

1. The Goths in Europe in about the fifth century, showing the extent of Gothic influence across the continent

When the Visigoths migrated to Spain, Theoderic installed his grandson Amalaric as king of the old Visigothic kingdom of Toulouse, and it appears that Theoderic was entertaining a grand scheme of united Gothic kingdoms. But the Ostrogothic kingdom began to collapse after Theodoric's death in 526, and the Visigothic throne was a bloody affair: four successive kings were assassinated 531–55. Indeed, this tendency of the Goths to dethrone sovereigns became known as the 'Gothic disease', and prompted Gregory of Tours to remark that 'the Goths had adopted this detestable custom of killing with the sword any of their kings who did not please them, and of appointing as king whomsoever their fancy lighted upon'. The Kingdom of Toledo nevertheless left behind some of the defining institutions of mediaeval monarchy: the coronation oath (first recorded in 638) and the anointing of the monarch with holy oil (672).

Gothica

The founding myths of the Goths derive from the brief period of Ostrogothic sovereignty over the Visigoths. The identification of a shared Gothic origin enabled barbarian history to give a new perspective on the Romano-Christian world. True universality could only be achieved from the Christian world view, so emphasis shifted to those areas and peoples of the world not covered by classical geography and ethnography: the barbarians. The principal works of these pioneering Gothic historians are the lost *Historia Gothorum* of Cassiodorus, Jordanes' *Getica* (based on Cassiodorus), Gregory of Tours' *Decem libri historiarum*, Isidore of Seville's *Gothic Histories*, and Paul the Deacon's *Historia Langobardorum*. There is, however, very little consensus among these different works.

Jordanes' *Getica* (*De origine actibusque Getarum*) was written in Constantinople in about 551. It was in part a digest of Cassiodorus' lost twelve-volume work, which appears to have focused on the genealogy and history of the house of Amal, the ruling dynasty of

the Ostrogoths. Although the extent to which Jordanes' account of the advent of the Goths was derived from Cassiodorus is now impossible to ascertain, he certainly focuses on the Ostrogothic empire in Italy and the legitimation of the Amali, and he may also have taken details of the prehistory of the Goths from the earlier work—although Jordanes prefers literary to historical sources, which he claims to supplement with oral tradition: the 'ancient songs' of the Goths. Significantly, however, the *Getica* is the first extant history to identify the homeland of the Goths as Scandza: Scandza is *vagina nationum*, usually translated as the 'womb of nations', as well as the 'bosom' or 'hive' of races—thereby instigating the imagery of Gothic fertility. But *vagina* also meant 'scabbard' or 'sheath', suggesting not simply birth but also war.

Scandza was no Mediterranean peninsula but a northern island of fertile pasturage, primitive dwellings, and bad weather—comparable in Jordanes' account to Britain, and located in southern Scandinavia. From Scandza, the Goths migrated to Scythia, thence to Dacia, Thrace, and Moesia (the area surrounding modern Transylvania). They were a learned people who worshipped Mars, who 'was reputed to have been born among them'. They subsequently migrated to the Black Sea, where they divided into Visigoths under the Balthi dynasty and Ostrogoths under the Amali. Their various homelands along the way had been characterized by swamps, forests, and mountains—indeed, in the eighth century Paul the Deacon developed this into a climate theory for Gothic history: the northern extremes made the Goths so vigorous and fecund that they had to migrate from Scandza due to overpopulation.

By positioning the Goths in the Baltic Jordanes therefore refigured the barbarian 'other' and effectively remapped the world: the frozen wastes of the north and the deep forests of Germany became new imaginative coordinates and helped to de-centre Rome as the cultural and intellectual focus of the known world. Jordanes' *Getica* is therefore a groundbreaking

myth of origin, but it did not attempt to supersede the Empire. Rather, the chronicle presents Gothic and Roman histories as interdependent, culminating with the triumph of Justinian and the incorporation of the Goths after nearly 2,030 years literally in the wilderness—a symbolic unity of Goths and Romans. And of course the *Getica* was also written against the backdrop of Visigothic and Ostrogothic settlement in areas previously governed by Imperial Rome, and Theodoeric's ambitions for the Amali to rule over both of these territories. If the Visigoths and Ostrogoths were actually one and the same people, there was therefore a historical justification for Gothic unification.

This theme was developed in the early seventh century by Isidore of Seville, the most prolific and influential Latin writer of the period after Augustine, and the most comprehensive chronicler of the Visigoths in the *Chronicon Gothorum* (619 and 624). Isidore's work focuses on the Gothic settlement of the Iberian peninsula. He does not locate the origin of the Goths in Scandza, adopting instead the biblical heritage proposed by Josephus, and the Visigoths consequently inhabit a very different landscape from the swamps, mountains, and forests typical of Jordanes—Spain (*Hispania*) is a temperate pasture. But like Jordanes, Isidore does relegate the significance of Imperial Rome by creating an alternative historical perspective—the provincial—and this is tied to the establishment of the Christian Church. The notorious violence of Visigothic monarchies is presented as the result of their adherence to the Arian heresy (which disputed the divinity of Christ), and Isidore attributes the eventual deliverance of the Visigoths to their conversion to Catholicism.

Other commentators made the same equation. In Bede's *Historia Ecclesiastica gentis Anglorum* (731), the peregrinations of the Angles (*Angli*) validate his historical narrative as a triumph of Christianity—specifically the Catholic Church—over the other ethnic groups (Britons, Scots, and Picts). For Bede, the Angles

have the strongest Christian credentials and therefore triumph over the 'Celtic' Christians (Scots) and the sinful Britons.

In Bede, the Angles represent the whole of the Germanic *adventus*—Angles, Saxons, and Jutes. Bede departs from his source in naming these three migrating tribes, and in implying that Hengist and Horsa, the legendary kings of Kent, were Jutes. The mysterious Jutes are named by Bede because they are in fact the Goths, and for later historians this opened the tantalizing prospect that the Geat culture described so vividly in the epic *Beowulf* was essentially and archaeologically Gothic.

Like Isidore and to a lesser extent Jordanes, Bede's understanding of national origins was essentially tied to the Gothic foundation of the Church rather than to an identifiable ethnic group in a mass migration: it was conversion to Christianity that gave the Angles a coherent identity (and a historical dynamism), not their ethnographical origin. But what is also notable in the British story is that it is a history of the assimilation of Germanic tribes rather than of their violent invasion. The seventh century hoard discovered at Sutton Hoo in 1939 tends to confirm this, bearing witness to a diverse range of European traditions and funerary ware rather than a purist ethnic identity. These Goths were cosmopolitans.

Chapter 2
The ascent to heaven

The *Getica* of Jordanes settled the definition of the Gothic for the next thousand years. The Goths were a missionary force that had emerged from outside Graeco-Roman civilization, revealing its geographical, historical, and theological limitations. The Goths had not only sacked Rome and overrun the old Empire, they had effectively sounded the death-knell of the classical pagan world. Through the writings of Augustine and Orosius, Pope Gregory the Great's later account of sixth-century Italy and Spain in his *Dialogues*, and the successors of Jordanes from Isidore of Seville to Paul the Deacon, the spiritual crusade of the Goths developed into a historical strand in the rise of the Catholic Christian church and its establishment across the nations and regions of Western Europe.

This may help to explain how, when Catholic orthodoxies were first questioned by the emerging Renaissance, a new definition of the Gothic was conceived—a definition that primarily focused on mediaeval architecture and culture. The post-classical past was judged aesthetically, and condemned as bad art. No-one living in Europe between the twelfth and fifteenth centuries would have characterized the churches and abbeys, colleges and parliamentary buildings that were constructed in this period as 'Gothic' any more than they would have identified themselves as living in the

'Middle Ages'. Their buildings were state-of-the-art, precision works of engineering and mathematical genius; only now are they perceived as 'High Gothic'.

Nonetheless, by 1510 the pioneering Renaissance architect Donato Bramante (1444–1514) was already dismissing all European styles that were non-classical and non-Mediterranean as 'Germanic': 'squat little figures, badly carved, which are used as corbels to hold up the roof beams, along with bizarre animals and figures and crude foliage, all unnatural and irrational.' The obvious connection was rapidly made. Much like the original classical historians before them, Renaissance scholars conflated the Goths with the German tribes that had threatened and eventually overcome Imperial Rome. Thus the 'Middle Ages' or 'dark period' was invented by Italian Renaissance humanists as the period following the fall of Rome and prior to the beginning of the modern period.

By the 1530s, the painter and biographer Giorgio Vasari was explicitly referring to 'Gothic' architecture to distinguish the mediaeval period from the classical. In his *Lives of the Artists* (first published in 1550 and revised in 1568) Vasari described the style as 'monstrous and barbaric, wholly ignorant of any accepted ideas of sense and order'. Anything post-Roman was 'invented by the Goths.... It was they who made vaults with pointed arches...and then filled the whole of Italy with their accursed buildings.'

The values of Renaissance architecture are clear in this attack on the previous epoch. The Renaissance was a classical revival based on humanist principles. In architecture, it favoured symmetry and balance, simplicity and elegance, decorative restraint, and human dimensions and perspectives. As John Evelyn, the seventeenth-century diarist, noted: 'The ancient Greek and Roman architecture answered all the perfections required in a faultless and accomplished building', but the Goths and Vandals had destroyed these and 'introduced in their stead a certain fantastical

and licentious manner of building: congestions of heavy, dark, melancholy, monkish piles, without any just proportion, use or beauty.'

The salient features of what has become known as Gothic architecture were delineated by Bramante and Vasari and their followers: roof bosses and corbels, beamed ceilings, gargoyles, tapering pillars, accumulated features, profuse decoration, pinnacles, buttresses, patterns of foliage, vaulting, and the pointed arch. But it was not until the early nineteenth century that there was any attempt to categorize the order or evolution of these mediaeval styles. Despite its anachronism this system remains the most straightforward and concise way of making sense of some half-millennium of building fashions. Moreover, it reveals the extent to which the predominant architectural style of the Middle Ages was discursive and pluralistic: Gothic 'crossed' building types.

In *An Attempt to Discriminate the Styles of English Architecture from the Conquest to the Reformation* (published 1812–17) Thomas Rickman identified the prevalent Gothic styles, dated by the reigns of monarchs:

Norman Gothic 1066–*c.*1180 (William the Conqueror to Henry II),
Early English Gothic *c.*1180–1275 (Richard I to Henry III),
Decorated Gothic 1275–1375/80 (Edward I to Edward III), and
Perpendicular Gothic 1375/80–1520/30+ (Richard II to Henry VIII).

Later commentators such as Paul Frankl and Nikolaus Pevsner have contested, dismantled, and reworked these categories at length, but for the present purposes Rickman's orders of Gothic architecture are a useful framework.

Norman

Norman Gothic architecture developed from the Romanesque style, which had in turn derived from Carolingian designs of the

eighth and ninth centuries. The style was effectively determined by the limitations imposed by the primary building material: stone. Hence these buildings are usually based on symmetrical square plans with round towers. They have thick walls, and windows are limited in size and number. They are characterized by rounded arches for doorways, windows, and interiors. They are low, heavy, dark, and, in a word, massy.

Norman Gothic was the default ecclesiastical architectural style in England for over a hundred years. It was favoured by the Benedictine Order, predominant in the country since before the Conquest, as it enabled the construction of monumental projects: several of the great English abbeys, such as Malmesbury in Wiltshire, were Benedictine foundations—massively and resolutely Norman in style and substance. Indeed, the Benedictine Abbey of Cluny in France was the largest building in Europe until the restoration of St Peter's in Rome.

Two significant structural innovations of Norman architecture allowed such large buildings to be planned and built: the development of ribbed and domed vaults, and buttressing. Rounded tunnel arches were used to support the weight of the building's walls, and more complex structures such as towers could be supported down the vertical sides of an arch. But rounded arches could be doubled up to create a ribbed vault, in which the load was distributed from the apex of the vault down ribs and across the four arches. Such a design was therefore exposed on all four sides, literally opening up space in the interiors of buildings. The ribbed vault could moreover support rectangles rather than just square floors or roofs, or circular towers, so buildings could now have long naves and impressively open aisles. Likewise, buttresses (flat rectangular supports standing slightly proud of walls) allowed the construction of larger buildings: everything could be built on a much grander scale. What was to become and be called Gothic architecture emerged from these Norman structural innovations.

First pointed or early English

Rickman identified the introduction of the lancet window as the single most recognizable characteristic and significant architectural innovation of Gothic architecture. In Carolingian and Norman buildings, windows had been small and insignificant due to the limitations of building expertise: walls with large openings were simply not able to support the heavy masonry of construction. But lancet windows could provide support because pointed arches had much greater load-bearing qualities than rounded arches (see Figure 2).

This meant that windows could be much larger and, in addition to being arranged singly, they could also be grouped together, such as in the 'Five Sisters' of York Minster—five lancet windows, each 50 foot (over 15 metres) high. Lancets could be narrow, pointed arches, or they could be widened into 'equilateral arches' for doorways, and pointed arch ribbing also allowed for higher, stronger vaults. The pointed arch became ubiquitous: windows, doors, vaulting, cloisters, clerestories, galleries, niches were all pointed arches, and it was also used as a decorative motif. Moreover the pointed arch was functional as well, allowing increasing amounts of natural light into hitherto dark buildings. The result was that large stone constructions could become lighter, more open spaces—far from emphasizing their sheer material solidity, these holy buildings began to develop into vast sculptures of light that reached up in supplication to the heavens.

The pointed arch probably first appeared at St-Étienne in Caen 1110–20, then in the choir of the church of St Denis, Paris, dedicated in June 1144, and the great choir of Notre Dame was begun in 1170—hence at the time this was known as 'the French Style' (*opus Francigenum*). The huge choir of Canterbury Cathedral was commissioned in this style after the Norman choir was destroyed by fire in 1174, giving the pointed arch early and widespread exposure and placing Canterbury in the vanguard of

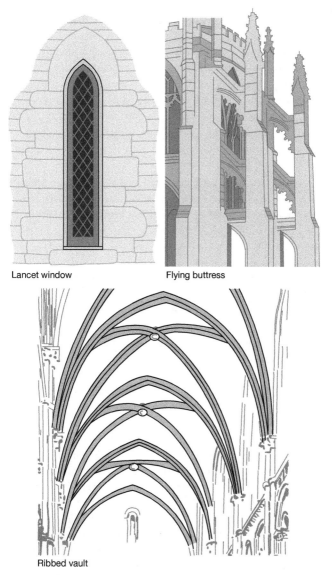

Lancet window

Flying buttress

Ribbed vault

2. The load-bearing qualities of the pointed arch, ribbed vault, and flying buttress precipitated a revolution in architecture and culture. These innovations combined to inaugurate Gothic architecture

design alongside Notre Dame, St Remi, and other French cathedrals. The style also became associated with the English saint, Thomas Becket, who had notoriously been martyred in the cathedral in 1170. This event became part of the fabric of the building, not simply as a popular shrine, but in the symbolism of the architecture. The Gothic style had significant moralizing potential, and the pointed arch could be linked to theological concepts of order and hierarchy. Gothic buildings were literally edifying: an edifice of the divine.

It was probably Wells Cathedral that had the first choir in which every arch was pointed. Purbeck marble, a characteristic Dorset limestone, was quarried for the supports, so instead of heavy pillars, columns developed into slender clusters often decorated with vertical hollows and fillets, producing an ornamental cross-section and an increasingly Anglicized feel. English architects were also initially reluctant to embrace the flying buttress to create height: they preferred to disguise such components and instead concentrate on length and the horizon of the aisles and naves, and on decoration. Winchester, Whitby, and Ely adapted the Canterbury model to develop a more English style, although the most striking example of the time is Salisbury Cathedral (1220–68), which is quite distinct from the continental High Gothic of a cathedral such as that of Reims.

The Cistercian Order, which was gaining in influence and property and tended to be architecturally more adventurous than their Benedictine brethren, encouraged the adoption of pointed-arch designs—not least because the reduced need for masonry made them superbly economical. But with anti-French sentiments rising sharply in the early thirteenth century, Early English Gothic began to develop independently of continental innovations as an expression of an emerging national identity, and Anglo-Saxon saints and the effigies of Saxon bishops were enthusiastically incorporated into the new ecclesiastical designs.

Decorated

First pointed marked a decisive move away from Carolingian and Norman architecture and therefore from earlier culture and history. This independent development continued in response to the 'Rayonnant' style that was spreading from France across Europe, characterized by the radiating, repetitive, and polychromatic decoration of window tracery seen in High Gothic continental cathedrals such as those of Chartres and Amiens. English Decorated Gothic, in contrast, favoured huge pointed arches patterned with mullions and tracery; although Rayonnant *was* patronized by Henry III—which is why Westminster Abbey looks unlike any other major English Gothic building. Westminster in turn proved influential in spreading rose windows to, for example, Binham Priory in Norfolk.

The equilateral arch helped to make English Decorated possible because a larger, wider space could be decorated. Windows were ornamented with trefoils and quatrefoils— geometric designs based on three or four intersecting circles (notable examples are in Exeter Cathedral and York Minster). English tracery designs developed far more rapidly than they did on the continent, as seen in the complexity of York's west window. There was a huge multiplication of ornamentation at every level and in the tiniest details, from curvilinear window tracery to structurally precise, articulated vaulting that enhanced the vertical height of pillars and arches. This fascination with tracery and detail and exaggeration and even carnival had an almost Eastern, arabesque flavour but probably had more immediate sources in the domestic court decoration favoured by Edward I (1272–1307). Pointed arches and clusters of columns were now bearing much heavier loads than was possible with rounded arches or classical columns, enabling buildings to become taller, and higher spires to be raised— suggesting that the building itself was an aid to meditation, a means by which to ascend.

Decoration was not confined to the masonry and woodwork. Interiors were richly ornamented: canopies were painted and structural features were picked out in red. This architecture drew on the human scale of reliquaries, and canopies, stained glass, and statuary enclosed space within the building, creating private, sanctified niches filled with coloured light. The whole church was an image of Heaven.

The church was also the centre of communal life: towers doubled as lookouts and lighthouses, plays and civic ceremonies were played out before façades, classes were held and business conducted. Gothic designs consequently became woven into popular culture. In Chaucer's *Miller's Tale*, the foppish Absalon sports fancy footwear decorated with the pattern of the east-end rose window of Old St Paul's Cathedral. The period has also been recognized as one of the great epochs of parish architecture in England, during which some 9,000 churches were built in England and Wales. It is also significant that Gothic became the preferred style for institutions from universities to seats of power. In Europe, state Gothic culminated in the French Flamboyant style of exaggerated, flame-like extremities and ogee (double-s) arches; in England, it culminated in Perpendicular Gothic.

Perpendicular

Perpendicular, also known as the Rectilinear style and International or Late Gothic, is probably the first style of architecture that can properly be called 'English'. Prior to this, the Gothic in England had adapted and reworked continental models—often radically, but the essential fabric remained the same. With Perpendicular, however, English architecture finally capitalized on continental innovations and the resulting skeletal structural framework and glass walls created a new architectural lexicon. Flying buttresses and ribbed vaults could support towering external façades and ever loftier spires, and because of the weight-bearing qualities of pointed arches, the walls between the

buttresses could all effectively become vast, pointed-arch windows and filled with stained glass. The Perpendicular is characterized by vertical elevations, emphasized by windows, columns, and decorative panelling inside, and buttresses and pinnacles outside—probably the finest example is King's College Chapel, Cambridge (1446–1515).

Inside, the building was all space and light—it was not made of heavy supporting walls but of slender columns and ribs and windows. Walls were reduced as much as was practically possible, while windows were extended to immense size, giving an extraordinary and hitherto unimagined sense of space and light—finally accommodating the possibilities of the Rayonnant style. Vaulting became finessed into dizzying and purely decorative fan shapes that disguised the structure of support, and columns were dressed with foliage. Wooden roofing adopted the hammerbeam style (made of upright hammer posts and brackets), which also opened up the interior and allowed for further decoration with roof bosses, themselves carved with a variety of secular and sacred images from geometric patterns, flora and fauna, and sacred images, to folkloric motifs such as tinners' rabbits and the Green Man.

English cathedrals were notably long; they were also very diverse and varied in their decorative and constructional history, often combining features from centuries of Gothic taste. This was in contrast to continental practice, which tended more towards a unified conception. Later commentators likened the confusion and uniqueness of English Gothic to the national temperament: it gave a sense of liberty and exuberance even within sacred space. But they also had a far more profound purpose: these buildings were *tours de forces* of mediaeval technology that demonstrated the order and malleability of the material world. Their complex vastness suggested the unimaginability of the divine: the perspectival interpretation of space was linked to the philosophy of the infinite.

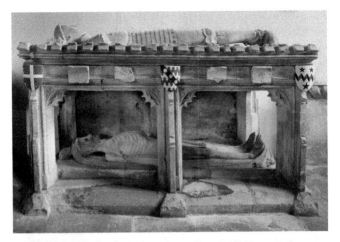

3. The cult of the macabre: a two-tier cadaver tomb. Beneath the splendid figure of Sir John Golafre, recumbent in full armour, lies his grotesquely withered corpse. Golafre died in 1442, but his monument may have been completed before his death as a *memento mori* (St Nicholas's Church, Fyfield, Berkshire)

The grinning skull

The spiritual meaning of architectural Gothic was therefore in space and light, artistry and craft, everyday life and spirituality—ironically, it ultimately led to a style associated with the darker side. As Johan Huizinga has noted, there was a whole cultural landscape of death in the Mediaeval period:

> An everlasting call of *memento mori* resounds though life.... The medieval soul demands the concrete embodiment of the perishable: that of the putrefying corpse.

Death was omnipresent. This was not simply a fact of living with the terrifying mortality rates of the Black Death, which killed up to 60 per cent of the European population between 1348 and 1350 (and may also have spelt the end of the labour-intensive

Decorated Gothic) rather, there was also a culture of death that was centred on churches. This encompassed chantries (endowments of Masses for the soul of a patron), commemorative brasses, pilgrimages to saints' shrines, perpetual monastic reminders of the fallen human condition, and a growing theological emphasis on Christ's suffering. But although society was ridden with guilt by virtue of the all-seeing eye of God, it also afforded opportunities for sardonic wit, and memorials could be highly individualistic and secular in tone. This emphasis on mortality eventually developed into a cult of the macabre, revelling in the plight of the body. 'Cadaver' tombs of the fifteenth century, such as that for Archbishop Chichele in Canterbury Cathedral, depict a recumbent figure in prayer while underneath lies an emaciated corpse, representing both the embodied public office and the decomposition of death (1426). This morbid funerary art would become a source for later Gothic associations of fear and the supernatural (see Figure 3).

Chapter 3
The iconoclasts

If there is a signal moment in charting the Gothic through history, it comes with the Reformation. This religious movement was promoted by Henry VIII and his son Edward VI and, despite the ensuing Counter-Reformation of Queen Mary, decisively sundered England from Catholic Europe. Hundreds of religious foundations were dissolved: their leaders were executed, their members scattered, their libraries ransacked or lost, and, crucially, their abbeys and priories were pillaged and fell into ruin. The English Reformation compounded a growing sense of national exceptionality with a thoroughly destructive attitude to the past. Henceforth, English identity was rooted in violence on a terrifying scale.

The modern Protestant state of England that eventually emerged therefore held an awful truth at its core: it had come into being at a terrible human and cultural cost—although this inconvenient fact was unsurprisingly repressed as the myth of English self-determination and progress gained momentum. The English imaginative encounter with the physical remains of its mediaeval heritage and all that this represented was now inevitably entwined with loss and devastation: first, of a venerable architectural tradition that had itself been increasingly, characteristically English; second, of the hundreds of Protestant martyrs who had subsequently been executed as heretics during the vengeful period

of Counter-Reformation under the reign of Queen Mary—'Bloody' Mary. The puritanical zeal that had inspired the decapitation of religious statues and had rioted across decorative church stonework, woodwork, and stained glass had led to an equally extreme backlash of unremitting severity. The hideously mutilated churches that remained in use and the crumbling ruins of ecclesiastical masonry strangled by ivy that lay abandoned no longer tied the country to earlier mediaeval history—rather, they were melancholy sites haunted by the ghosts of recent times, sacrifices to progress.

Reformation

Gothic architecture and the mediaeval fascination with death in martyrologies, relics, chantries, and the cult of the macabre remained the cornerstone of popular religious culture in early sixteenth-century England. The *memento mori* tradition, for instance, is recorded in an account of one John Fisher, who when saying Mass was 'always accustomed to set upon one ende of the altar a dead man's scull, which was also set before him at his table when he dyned or supped'. Although Britain was at the edge of the Catholic world, geographically peripheral and politically marginal, its ecclesiastical art was consistent with the rest of Europe. Churches were filled with images of saints carrying the instruments of their martyrdom, and walls were often decorated with depictions of the Day of Judgement and Purgatory. The 'Dance of Death', a series of allegorical images that represented mortality in a perpetual choreography with day-to-day life, arrived from the continent in the 1440s and proved highly popular.

At the same time, there were murmurings of discontent. There was a growing mood of iconoclasm (the destruction of ecclesiastical images): reformers such as the Lollards objected to saintly cults and pilgrimages, and the Humanist scholar Erasmus criticized in particular the shrines of Thomas Becket, and those at Walsingham. In 1517, in Wittenberg, Germany, Martin Luther had

nailed his Ninety-Five Theses to the door of Castle Church and so precipitated a debate on the comparative spiritual value of faith as against good works—good works meaning giving alms, sponsoring chantries, or venerating saints. There were spontaneous attacks on churches determined to destroy holy images as idolatrous. Such heresy was a capital offence: some protesters were executed and the writings of Luther were banned in England in 1528.

The English monarchy had of course hitherto been devoutly Catholic, but Henry VIII (1509–47) was facing a political crisis: his wife, Catherine of Aragon, had produced no royal heir. This domestic drama was played out on the national stage as the king obsessed about divorce and remarriage. Under the influence of Lutheran theologians and the growing reformist movement on the continent, Henry gradually developed a new agenda. Over the next twenty-five years, this would completely overthrow papal authority.

In 1533, legislation was passed removing papal jurisdiction and allowing the English Church to grant divorces independent of Rome. The Act of Supremacy followed in 1534, ensuring that church taxes were henceforth paid to the king, not the Pope. There were calls for the reform of ecclesiastical ceremonies and customs, highway crosses were cast down and figures of saints effaced or ripped out of shrines. When Thomas Cromwell, Henry's chief minister, undertook a tour of monasteries in 1535, his aim was to end monkish superstition and in particular the cult of the saints. Relics were deliberately ridiculed: St Mary Magdalene's comb, coals that had roasted St Lawrence, bits of saints that turned out to be bits of pigs—this constituted the superstitious lumber accumulated from centuries of Catholicism.

Shrines and images were formally denounced as idolatrous in 1538, and pilgrimages condemned. Becket's shrine at Canterbury was specifically targeted: by pledging his support to Rome, Becket had rebelled against his king and so this case was seen as symbolic of the earlier authority of the church over the throne. The King's

Council ludicrously ordered Becket to appear within thirty days; when he failed to do so, his shrine was demolished. Becket's ancient bones were exhumed and publicly burned, his treasures and *ex votos* went to the king, and his name was erased from church books. The speed with which the English Reformation suddenly took hold is clear from the Gothic screen behind the altar at Winchester that held statues of many saints: it had only been finished in 1528; a decade later it was condemned.

Dissolution

Acts were passed to dissolve the English monasteries in 1536 and in 1539. Within four years, over 800 religious houses disappeared. The built environment of abbeys and their social structures of monks, friars, and nuns, as well as the artisans and craftsmen and labourers who supported them, were entirely dismantled and England turned its back on the past.

The despoliation of the abbeys generated a terrifying momentum of riot and pillage. Local people joined in simply so as not to be left out: 'I did as others did' was one reason given for the destruction. Once they lost their legal status, the buildings were gutted: lead was stripped, windows and doors were removed, roofs and masonry were plundered for cheap building materials. Contents were auctioned on site or sent to the king: the five abbeys of Bury St Edmunds, Ely, Ramsey, Peterborough, and Crowland produced two-thirds of a ton of silver, as well as gold and other valuables. Ancient libraries and archives were also dispersed, and the intellectual cost of the dissolution is incalculable. Many of the superiors of these communities were executed as traitors—the Abbot of Glastonbury, for example, was hanged, drawn, and quartered on Glastonbury Tor—and monks were targeted by mobs.

The destruction continued under Edward VI, who was far more forthright in his Protestantism than his father. Edward was only nine years old when he succeeded to the throne and had been

raised to see himself as the destined champion of the English Church. He reiterated his father's declaration of royal supremacy and fully denied the intercession of saints (which entailed removing pictures, stained glass depictions, and even candlesticks from remaining shrines), he established an English-language Litany and introduced the book of common prayer. The existence of Purgatory was denied, which necessitated the whitewashing of wall paintings. Chantries were abolished in 1547, removing a major source of ecclesiastical finance, and chantry chapels were wrecked or fell into ruin. In 1550, altars were replaced by wooden communion tables, and any surrounding decoration was destroyed.

At Worcester, the Dean and Chapter wrote, 'Our Churche is greatly defaced, owr quear pulled down, owr belles and organs be broken, owr Altars and Chapelles are...violated and overthrowne', and the loss of the shrine at Walsingham was mourned in the verse 'Weep, weep, O Walsingham':

> Sin is where Our Lady sat,
> Heaven is turned to hell.
> Satan sits where our Lord did sway;
> Walsingham, O, farewell.

The dissolution of the monasteries revolutionized land ownership and had huge and irrevocable social effects, but also created an aesthetic of ruin. Decapitated images in stone and glass, mutilated and abandoned buildings, and inscrutable fragmentary remains testified to the violence of the dissolution, but were also now embedded in the landscape and the imagination in new ways. The attempts to break with history also revealed the inescapability of the past and the extent to which it haunted the present.

Counter-Reformation

The Reformation did not only attack the Catholic Church in England, it was also an assault on the nation's cultural and social

heritage. The iconography of the saints was effectively the art of the common people, and support for the old order was strong. In 1536 and again in 1549, rebels attempted to restore the old church—the leaders were executed and two were hanged from the steeples of their own churches. The destruction of rood screens, tombs, and statues often met with resistance. At Exeter, attempts to pull down the rood loft of the priory of St Nicholas were thwarted by 'certain women and wives [who]...came in all haste to the said church, some with spikes, some with shovels, some with pikes, and some with such tools as they could get'. The workman fled and escaped with a broken rib. He was lucky: two men engaged in similar activities at St Paul's were actually killed.

Then, in 1553 and after the nine-day wonder of Lady Jane Grey's reign, the old order was restored with the accession of Queen Mary. Catholicism was reinstated: churches were refurbished, monastic life was revived, and 300 Protestants—men, women, and children—were executed between February 1555 and November 1558.

This carnage was recorded by John Foxe in his huge work, *Acts and Monuments*, which went through four editions in Foxe's own lifetime (1563, 1570, 1576, 1583) and was eventually four times as long as the Bible. If the dissolution of the monasteries provided the architectural scenery against which the Gothic imagination would eventually emerge, Foxe's accounts of Protestant martyrdom created a literary model that was forensically focused on character, was powered by a fatal narrative arc, and explicitly mixed its sources. It was a comprehensive and readily accessible account of human suffering: most churches had a copy chained to the pulpit, and scores of popular abridgements were sold as Foxe's *Book of Martyrs*.

Acts and Monuments was a multiple, collaborative work of theological and antiquarian research that aimed to establish and reinforce the legitimacy of the Anglican Church. It was designed to supersede mediaeval hagiographies and their emphasis on

magic and miracle by shifting attention to the martyrdom itself, specifically to bearing witness. It was the Protestant version of *ars moriendi*—the art of dying well. Hence the title emphasizes *acts* (the lives of martyrs) and *monuments* (spiritual testimonials) over the superstitious idolatry of relics and miracles. The book contains no fabulous elements—indeed, the accounts are rooted in everyday life with details of place and time, biography and event—and no iconographic elements. These are martyrs from every level of society, from bishops to artisans.

Foxe's preference was to use the martyr's own words in first-person accounts. He often incorporated or republished earlier accounts and conflated sources, including oral traditions, and gave special prominence to last words: the power of final speeches was attested by attempts to silence victims because there was no reason to lie in the face of imminent death. The title-page emphasized the authenticity of the accounts—the authenticity being 'the euidence of God's spirit', not necessarily historical veracity. Scripture therefore provided typological parallels for real events, and Biblical allusion pervades the martyrdoms. But other literary models were also invoked, from letters to legal depositions, from sermons to folktales, and some of the martyrdoms have the contours of romance, even comedy. The emphasis, however, remains on telling eye-witness detail, such as how Cranmer unflinchingly placing his hand in the fire first, and so crowds are usually gathered at the events (see Figure 4).

Foxe's stark technique is well illustrated by the martyrdom of John Hooper, executed in the precincts of Gloucester Cathedral—his own cathedral. Hooper's burning was gruesome as the faggots of wood were too green to burn fiercely, and it was a windy day. The fire had to be rekindled twice before it took. Hooper prays, and all eyes are drawn to his suffering:

And these were the last words he was heard to utter. But when he was black in the mouth, and his tongue swollen, that he could not

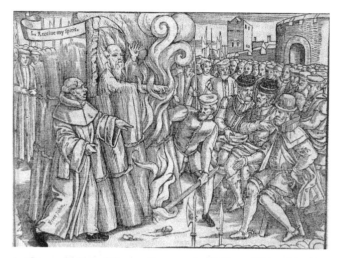

4. The martyrdom of Thomas Cranmer, Archbishop of Canterbury, at Oxford, 21 March 1556. Cranmer places his writing hand in the fire as repentance for his earlier recantation and speaks the words of St Stephen, the first martyr

speak, yet his lips went till they were shrunk to the gums: and he knocked his breast with his hands, until one of his arms fell off, and then knocked still with the other, what time the fat, water, and blood dropped out at his fingers' ends, until by renewing of the fire, his strength was gone, and his hand did cleave fast in knocking to the iron upon his breast. So immediately bowing forwards, he yielded up his spirit.

But Foxe's *Book of Martyrs* was not simply a compelling reading experience. It was also filled with illustrations: 'Look in the book of Martyrs and youle see | More by the Pictures then the History.' It may be ironic that a book written against idolatry was valued for its visual impact, but such was the case with *Acts and Monuments* and its abridgements. The title-page evoked pre-Reformation images of the Day of Judgement with Christ on a rainbow presiding over angels and devils, saints and sinners, and

there were 149 illustrations of martyrdom in the 2,300 pages of the 1570 edition. These often included words and reported speech, and were sometimes coloured by hand. The 1570 edition also had a large fold-out woodcut, which was a dramatic table of persecutions detailing different varieties of torture and execution; it may even have been used as a wall chart. Featured martyrdoms included being cast from a cliff, stoning and mattocking, disembowelling, inverse crucifixion, roasting on a griddle or a spit, immolation, being hanged by the hair, being torn apart by horses, various forms of suspension, being devoured by beasts, flagellation, extreme dentistry, having strips of flesh removed, branding and searing, boiling alive, and eye-drilling, as well as the more usual stabbings, dismemberments, and beheadings.

It is worth noting that in response to Foxe, Richard Verstegan, a Roman Catholic Anglo-Dutchman, produced a Latin martyrology illustrated with twenty-nine engravings. The *Theatrum Crudelitarum Haereticorum Nostri Temporis* (1587) detailed the persecution of Catholics in northern Europe and included Mary, Queen of Scots, executed in the year in which the book appeared. Verstegan's Catholic martyrs are clearly distinct from Foxe's staunch Protestant sufferers: they are less individualistic, they seem removed, in a state of transcendence. Their tragedies are played out in unidentified places independent of witnesses save their persecutors. They are already of another world.

Foxe's *Book of Martyrs* infused the English imagination with images of suffering and it is tempting to equate this not only with later Gothic writings that dwelt on pain and torture, persecution and death, but with also with Protestantism and nationalist politics. Foxe himself argues that English national origins are bound up with the origins and legitimacy of the English Christian Church, much as earlier Gothic historians had done. However, the advent of the Angles celebrated by Bede implied that the first English Church had been righteously Catholic. In contrast, Foxe proposed a primitive British form of Christianity, effectively a

prototype of Protestantism, and begins his history of the Anglican Church with the 'Britons' and the British mother of the emperor Constantine.

Foxe's attempt to develop a Galfridian version of history (one based on the 'Ancient Briton' theory of Geoffrey of Monmouth) was again countered by Verstegan, who revived Bede's theory that English national origins lay in the advent of the Germanic tribes. Verstegan was in fact the first to argue explicitly that the English were descended from the Anglo-Saxons. In *A Restitution of Decayed Intelligence: In Antiquities. Concerning the Most Noble and Renowned English Nation* (Antwerp, 1605), dedicated to King James I and VI, Verstegan argued that the English could trace their lineage via the Germans back to the tower of Babel. He claims that the German tribes had never been subjugated, invaded, or cross-bred, or even adopted foreign words into their language, and that sovereigns ruled by elective consent. Verstegan does not attribute this purity to climate theory, but to 'heritable custom'.

This account of an essentially Gothic national identity proved immensely influential: five editions of *A Restitution of Decayed Intelligence* were published 1605–73. And although Verstegan's aim was to prove that Germanic racial origins coincided with the legitimacy of the Roman Catholic Church, the work was subsequently championed by Puritans such as William Prynne because it laid the foundations for antiquarian investigations into constitutional history. But, before turning to seventeenth-century Gothic political theory, there are further literary influences to add to the contradictory heritage of Foxe and Verstegan.

Chapter 4
The revenge of the dead

The Reformation not only stripped the church of its pageantry and ritual: the whole calendar of customs and lore—the fabric of everyday life—was dismantled. Foxe's *Book of Martyrs* explicitly rose to the challenge of this new national order and developed a theory of English Christianity, but the religious turmoil of the sixteenth century also had a profound if more implicit influence on other writings of the period. This chapter will argue that literature helped to fill the imaginative void that was left after the Reformation and Counter-Reformation, and that it is from these texts that later Gothic writers took their inspiration and much of their material.

In addition to Foxe's *Book of Martyrs*, two key bodies of work carried the imaginative impact of the Reformation through seventeenth- and into eighteenth-century literature: the popular ballad tradition, and the plays of the Elizabethan and Jacobean stage, notably 'Revenge Tragedy'. Each proved to be a significant constituent of the emerging English national identity: in the undecidable characterization they presented, in the eerie glimpses of the Elfworld they offered, and in the dreadful persecutions they delineated. Together they bequeathed to the English imagination an extraordinary carnality. Accounts of mutilation and mayhem presented the body as something forever

being prised apart and brutally dissected, perhaps not unlike the state of the nation itself at the accession of James I and VI in 1603. These songs, narratives, and plays resound with questions of existence: what lies within—is it the soul, a ghost, or merely an enigmatic emptiness? From such sources the Gothic imagination, already built of pointed arches and crumbling cloisters, was furnished with a rich, if decaying, splendour of plot and imagery: of imprisonment and incarceration, rape and torture, revenge and retribution; of dismembered body parts, walking corpses, and spirits; of annihilation and extinction. From this infernal region would emerge a new genre of literature.

Ballads

Ballads—popular verse narratives that could be sung, recited, or read—helped to fill the imaginative vacuum left by iconoclasm. The world of balladry is an archaic, 'merrie' England populated with heroes and lovers, villains and outlaws, elves and fairies; it is governed by saints' days and festivals, custom and superstition, and its sovereigns are rulers by absolute power. And yet at the same time society is lawless and its princes are capricious. Violence is explicit and extreme, frequently inexplicable and unpunished: the guilty usually go free—if caught, their motives remain obscure and their values are at best amoral. Retribution and redemption are rare, but when they do come, they are crushing and often unexpectedly driven by supernatural agencies. There is no escape from the inexorable narrative.

The appalling tale of 'Lamkin' tells of the cold-blooded torture of a baby simply to rouse his mother, the lady of the house:

> 'We'll prick him, and prick him
> all over with a pin...'
> And the nurse held the basin
> for the blood to run in.

The mother is raped and murdered, and the narrative welters in blood:

> Here's blood in the kitchen,
> here's blood in the hall,
> Here's blood in the parlour
> where my lady did fall.

Long Lankin's motives are never revealed and he dies mute and unrepentant on the gallows—his only testimony is in his crimes.

By dwelling on sex, rape, torture, mutilation, dismemberment, decapitation, death, and even in some cases cannibalism, the emphasis is firmly on the physical realities of suffering. But those who suffer are not martyrs. Death is not presented as an escape or state of grace, it is not a form of sacrifice—it is merely a crushing reassertion of the material nature of reality. Hence balladry effectively marks the beginning of the true-crime narrative. Foxe's forensic style of eye-witness testimony and specificities of time and place were developed by the 'murder ballad' tradition and proved to be particularly suited to the anonymity and *mise-en-scène* of urban environments. Ballads therefore act as a repudiation of Foxe: there is no redemption in the post-Reformation world, just ruins and the ghosts that haunt them.

Ghosts in fact have no place at all in Protestant theology: they are souls in Purgatory, a remnant of Catholicism, and the state of Purgatory had been rejected by Anglicanism in 1563 as the twenty-second of Thirty-Nine Articles. At best, ghosts are demons sent to delude and tempt (revealingly, the ancient Greek for ghost is *eidolon*, from which 'idol' and hence 'idolatry' are derived). But the compelling mix of life and death that characterized the cult of the macabre was tenacious and remained popular in uncanny tales of 'death and the maiden'. The ghosts of balladry are as unremittingly physical as the rotting corpses that adorned tombs and memorial brasses. They are horribly corporeal, decomposing before the eyes of lovers even as they visit them, or appearing as

premonitions of death and temptations to die. In 'The Unquiet Grave', a dead lover is roused after a year and a day. His truelove craves a kiss, although her mourning is now untimely:

You crave one kiss of my clay-cold lips;
But my breath smells earthy strong;
If you have one kiss of my clay-cold lips,
Your time will not be long.

'Sweet William's Ghost' is less forgiving: he seduces Margaret and she dies.

Likewise, the other-world of Faërie (or Elfland, a realm possibly derived from the fall of the rebel angels) is presented as prosaically consistent with the everyday world. The 'Cruel Mother' kills her own babies, but inadvertently summons supernatural vengeance by leaning against a thorn—the hawthorn being traditionally a gateway to Faërie. The mother is damned by her babes—'Heaven's for us, but hell's for thee'—revealing that she will be punished for her sins on earth. The ballad is a weird mix of Catholic theology and folklore, showing how pre-Reformation beliefs took refuge in superstition.

These supernatural ballads are both magical and amoral, but present elves as tangible beings subject to the strange laws of Faërie in their dealing with humans. Thomas the Rhymer, for instance, had legendary powers of prophecy as a result of his exile in Faërie, and the ballad of Thomas describes how he is compelled to leave the perilous realm as he is in danger of being taken by fiends as part of their hellish tithe on Elfland. In another Faërie ballad, Tam Lin, the fey seducer of Lady Margaret, faces the selfsame fate—he too escapes Elfland and the fiends but is cursed by the Queen of Faërie for what he has seen there. In both, an outdated Christian eschatology and odd fidelities underpin the superstition. It is a strange brew, and would prove to have a dramatic power on the stage.

Revenge Tragedy

Ballads had a significant influence on theatre: they suffused plays, supplying plotlines and creating frameworks of allusion and common reference. Songs were often directly incorporated into character's speeches, and popular plays were swiftly adapted as broadside ballads. But drama developed far beyond the terse and condensed narratives of the popular ballad tradition. In particular, Revenge Tragedy capitalized on ballad motifs with an almost hallucinogenic intensity that developed into a shockingly powerful new style and led directly to the Gothic fictions of the next century.

Revenge Tragedy twisted the hopeless caprice and senseless killing of ballads into a morality of revenge. The law forbade it, the Bible made it God's prerogative, but revenge was, as Francis Bacon noted, a 'wild kind of justice': 'They reck no laws that meditate revenge' (Thomas Kyd, *The Spanish Tragedy*, c.1587). The extreme forms of vengeance within these plays exaggerated and repeated death until the entire social fabric collapsed. Whole families or dynasties were carried away in its wake and the old order was left in ruins. Christopher Marlowe comments on theologically provoked violence in *The Massacre at Paris* (c.1592), which describes the mutual persecutions of Protestant Huguenots and Roman Catholics and the resultant bloodbath of mutilation, death, and desecration, but in this drive for annihilation, plays also more directly mirrored the heedless, retributive ethics that had smothered English politics since Henry VIII's divorce from Queen Catherine.

It is worth emphasizing that Revenge Tragedy had little to do with classical Aristotelian tragedy—*hubris*, *hamartia*, and *catharsis* have no place here. The flaw is as much in the world itself as it is in character: the 'time is out of joint', as Hamlet grimly observes. This condition shares in the amorality of ballads and older English aesthetics of doom, but also with Senecan tragedy: Roman dramas of revenge in which the crimes of the past erupt into the present. There is little dignity in suffering in Seneca's plays, rather nobility

The Gothic

lies in Stoicism and so characters onstage act like witnesses, taking their time to ponder in long declamatory speeches the devastation that surrounds them.

The tangled plots of Revenge Tragedy are dominated by sexual crimes and hideous violence, discovered in dreams and by conspiracy, entangling individuals in court intrigue, and dealt with ultimately by extinction and often ghastly humour. The action is shocking: Shakespeare's early play *Titus Andronicus* (*c.*1593), written under the ghoulish influence of Marlowe (possibly even with Marlowe's assistance), includes honour killing, gang rape, three severed hands and a ripped-out tongue, and a brutal climax of cannibalism. It also, coincidentally, has a wickedly scheming character Tamora who is the queen of the Goths. The blackest humour runs through this play: when Titus is tricked into severing his own hand, he can only respond with horrid laughter.

Shakespeare's major tragedies draw powerfully on revenge motifs. In *Hamlet* (1600–1), for instance, there are poisonings and fatal stabbings, a ghost who feels the fires of purgatory, macabre scenes in graveyards with a disinterred skull and open graves, and madness and dreams, while above all hangs perverted kinship, murder, and incest. The cult of the macabre is invoked in dark jesting about rottenness, the materiality of food, bodies, and the Eucharist, and the disruption of funeral rituals. This northern, non-classical play, set in Denmark and ultimately derived from *Amleth*, a twelfth-century Norse saga of honour and vengeance, is a complaint about the suppression of history, of a certain sort of history: 'Antiquity forgot, custom not known'. It is a play about mourning the past, memory and forgetfulness, but also haunting. The revoked past rises like a revenant, manifested in dreams—bad dreams. Dreams are a foretaste of death, precursors of ghostliness:

> For in that sleep of death what dreams may come,
> When we have shuffled off this mortal coil,
> Must give us pause.

Hamlet, like other Revenge Tragedies, therefore dwells on the problems in discerning what is real: masks, secrecy, concealment, fears of counterfeits and impersonation, madness and feigned madness, glimpses of other worlds, and themes of disinheritance bedevil the maze-like action. Theatrical performances are made part of the plot of *Hamlet* and become sickeningly actualized—indeed, in the earlier *Spanish Tragedy* Hieronimo stages a play in which the actors are actually killed, and in the later *Revenger's Tragedy* (Cyril Tourneur or Thomas Middleton, 1607) courtiers playing in a masque use it as cover to rape the Duchess, who then poisons herself for shame. Nothing is clear: there is a restless confusion of multiple perspectives:

> There are more things in heaven and earth, Horatio,
> Than are dreamt of in your philosophy.

Dr Faustus wishes he had 'never read book'; meanwhile, in John Webster's *The White Devil* (*c*.1609), Flamineo complains that 'we confound | Knowledge with knowledge'.

Webster in fact drew heavily on Shakespeare for *The White Devil* and *The Duchess of Malfi* (1612/13), the former even including an allusion to Yorick when the ghost of Bracciano enters contemplating a skull—a doubled *memento mori*. Like *Hamlet*, Webster's Jacobean dramas also dwell on monuments, memory, and the shadow of the Reformation:

> I do love these ancient ruins:
> We never tread upon them but we set
> Our foot upon some reverend history.

But while Webster's Jacobean dramas are suffused with Shakespearean devices of madness, apparitions, sharp mockery of the physical human condition, and alienation, there are also distinctly individual touches: waxwork images, poisoned books and paintings and armour, a consort of madmen, even lycanthropy.

Webster's plays are moreover pervaded by a haziness that defeats clarity: 'Their life a general mist of error | Their death a hideous storm of terror' intones Bosola in *The Duchess*, and Antonio and Flamineo both come to their deaths 'in a mist'.

Ghosts, devils, witches

Shakespeare uses more ghostly apparitions in plays than any of his contemporaries, excepting perhaps Marlowe for the spiritual pageantry of *Doctor Faustus* (1604). Ghosts appear in several plays, and spectral images frequently blur in and out of dreams. In *A Midsummer Night's Dream* (*c*.1594–5), Robin Goodfellow recounts how the spirits of the dead buried in graveyards, as well as those lost at sea or suicides buried at cross roads, return to their mysterious dwellings as dawn comes: 'At whose approach ghosts, wandering here and there, | Troop home to churchyards. Damned spirits all.' The Ghost in *Hamlet*, in contrast, is a creature less of English folklore and more a radically ambiguous manifestation. If death is indeed 'The undiscover'd country, from whose bourn | No traveller returns', then how can the Ghost come back? Is it 'a spirit of health or goblin damned'? If it is from neither Heaven nor Hell but rather from Purgatory, then the Ghost becomes indefinable: an apparition that cannot be contained by conventional thinking, a Catholic superstition haunting Protestant faith. Such undecidability would prove highly influential in later ghost writing, but in the case of *Hamlet* it is as if the whole spiritual destiny of the nation has been bewitched into a spirit-led fate.

The Ghost in *Hamlet* is witnessed by others, but in *Macbeth* only the king sees the bloody corpse of Banquo and the air-drawn dagger, consistent with Renaissance theories in which ghosts were visible only to one person. Macbeth himself is repeatedly described as 'rapt', as if in another world, and the whole play seems to teeter on the margin between the material world and the dreamlands of Faërie. In his *Discoverie of Witchcraft* (1584), Reginald Scot argued that, 'in time to come, a witch will be as

much derided and contemned, and as plainly perceived, as the illusion and knavery of Robin Goodfellow', yet James I and VI was a firm believer in demonology, observing that 'since the Devill is the verie contrarie opposite of God, there can be no better way to know God, then by the contrarie'. This royal interest is of more than anecdotal interest: *Macbeth* mixes the legendary British past with ghosts, dreamlands, and witches. Like *Hamlet*, it ties theories of national identity and ancient remembrance to the supernatural forces of history.

King Lear (*c.*1605–10) also weaves nation and superstition together. Edgar, who eventually takes the throne, is mistaken for a ghost or demon by the Fool, and himself feigns visions of devils. Lear declares that both he and Cordelia are returned spirits, and when he does die, he virtually evanesces as Kent murmurs, 'Vex not his ghost'. Yet despite its imagery and its ancient British setting, *King Lear* contains no explicit supernaturalism—it is all in the atmosphere: in language and indeed in weather. *Othello* too is devoid of overt demonology, but is drenched in diabolical imagery. Iago is based in part on the Vice of fifteenth- and sixteenth-century Morality Plays—amoral, light-hearted, and seductive. Like Barabas in Marlowe's *Jew of Malta*, he deliberately performs his devilry and happily declares himself to be the midwife of atrocity. He is a metaphorical devil—no actual devils appear onstage in any of Shakespeare's plays, although they certainly did elsewhere. Indeed, in one performance of Marlowe's *Doctor Faustus* at Exeter, the alarm was raised and the production abandoned when it was noticed that there were one too many devils onstage.

The Devil himself, for all his supernaturalism, was in any case a more morally complex figure than the affable Vice. Marlowe's Mephistopheles is a pitiful husk, the wraithlike remnant of a fallen angel existing in perpetual and unutterable despair. The magic he performs is parlour magic, summoning up spirits much as poetry or the theatre can provoke a response. It is the sort of empty artistry that Prospero, Shakespeare's sorcerer in

The Tempest (1611), excels at. Mephistopheles knows that there is no hidden knowledge save of Faustus's own damnation— 'What art thou, Faustus, but a man condemned to die?'—but he cares not. 'Where are you damned?' asks Faustus. 'In hell', Mephistopheles replies, simply.

> *FAUSTUS*: How comes it then that thou art out of hell?
> *MEPHISTOPHELES*: Why, this is hell, nor am I out of it.

Mephistopheles is defined by his torment, the inevitable consequence of his insurgency against Heaven. He embodies the unrepentant political rebel, intellectual radical, and social outcast. It was a condition that later informed the depiction of Satan in John Milton's *Paradise Lost* (1667). Satan rallies himself with the assertion, 'Better to reign in hell, than serve in heaven', but he discovers that he is now defined by hell, is damnation itself: 'Which way I fly is hell; my self am hell'.

The figures of Mephistopheles and Satan had a pervasive influence in the construction of the outlaw Romantic poet, and the ballad tradition and Revenge Tragedy more generally bequeathed to later writers twisted plots of violence and lust, vengeance and despair driven by dreams and madness, supernatural beings, and a fearful respect for the nation's past, whether from ancient times or in recent political history. This is the template of Gothic literature, but it took a century and a half for this influence to be felt. In the meantime, the Gothic was consolidated in architecture and politics.

Chapter 5
Liberty Gothic

In the topographical poem *Coopers-Hill* (1642), one of the most-quoted works of the seventeenth and eighteenth centuries, the 'Cavalier Poet' Sir John Denham described the ruins left by the dissolution of the monasteries:

Who sees these dismal Heaps, but would demand.
What barbarous Invader sack'd the Land?
But when he hears, no Goth, no Turk did bring
This desolation, but a Christian King;
When nothing but the Name of Zeal, appears
'Twixt our best actions, and the worst of theirs,
What does he think our Sacrilege would spare,
When such th' effects of our Devotion are.

For many—Catholics, classicists, and indeed royalists—the Goths were still the barbarians at the gate. Yet there was a growing tide of opinion determined to revise this assessment and position the Goths as the forerunners of modern society. Although the political and theological cataclysm of the Reformation still reverberates today, it was not long before ruins were being rebuilt and the monkish architectural style of the previous epoch was revived. At the same time, antiquaries and political theorists were generating Gothic 'myths' of their own, stimulated by tensions between Charles I and Parliament. History was written and rewritten in

the context of political crisis. These debates focused on the origin and development of 'Gothic' forms of government, and critics of the monarch sought evidence from history to curtail the increasingly absolutist pretensions of the king. Such claims about the origin of English government formed the basis of much political discussion well into the next century as the following chapters will show—influencing the passage of the Act of Union, which joined the parliament of England and Wales with that of Scotland, and the response to the French Revolution.

Return of the Goths

Despite the classicism of the Renaissance, both the Elizabethan and Jacobean courts were mediaevalist in their pomp and pageantry and culture—indeed, the central literary works of the sixteenth century were deliberately reworkings of the mediaeval in Edmund Spenser's 'Merrie England' pastoral of *The Shepheardes Calendar* (1579) and the archaic and Arthurian *Faerie Queene* (1590–6). The invocation of an idealized past was a way of stabilizing the dynastic precariousness of the Tudors as it veered from Henry VIII and his six wives through Reformation to Counter-Reformation and the execution of Mary, Queen of Scots, before Elizabeth finally succeeded to the throne. By claiming kinship with the bucolic vision of legendary history the monarchy could present itself as having deep roots in the nation's vernacular culture, and by accepting the remnants of pre-Reformation festivity and folklore that lingered on in custom and tradition the recent turbulent changes could be calmed. Hence the crown and the court were transplanted to the Middle Ages. As Touchstone declares in the Forest of Arden in Shakespeare's play *As You Like It* (*c*.1599–1600), 'I am here with thee and thy goats as the most capricious poet, honest Ovid, was among the Goths'.

Gothic of course justified this connection with the mediaeval past. The Renaissance had laid the foundations for such a Gothic revival with the rediscovery of texts such as Jordanes' *Getica* (1442) and

Tacitus' *Germania* (1455), which offered new frameworks for understanding ancient history and national identity, and in his epoch-making work *Britannia* (Latin edition, 1586; English edition, 1607) William Camden drew heavily on these sources in his account of the Goths. According to Camden, the '*Gothick* Nations' swarmed 'from the Northern Hive' to the Black Sea and resisted all attempts at invasion and subjugation, being 'a most ancient people...invincible themselves, and free from any foreign yoke'. From here (Scythia), they spread across all of western Europe.

Angles, Saxons, and Jutes ('*Getes*'), as well as more circuitously the Normans—all were Goths. Indeed, the identification of Jute/Gete/Goth mooted by Bede and his school was enshrined in the first Old English dictionary (William Somner, 1649), which specifically located the Jutes in Kent. Moreover, in the later revised *Britannia*, the Lowland Scots were also presented as Goths, having 'the same German Original with us English'. Camden particularly applauded the evolution of this spirit into the 'morall and martiall vertues' of the Germanic races, and his account concludes by describing how widely and deeply Gothic blood ran in the dynasties of Europe:

> It cannot be disgraceful to the Scots, to own themselves the Progeny of the Goths: since the most Potent Kings of Spain value themselves upon that Extraction; and the Noblest Italian Families either derive their Pedigree from the Goths, or, at least, pretend to do it And the Emperor *Charles* V. was wont to say, in good earnest, That all the Nobility of *Europe* were deriv'd from *Scandia* and the Goths.

Far from being simply a barbaric interlude in history, then, the Goths had embedded themselves throughout Europe, and their descendants were spread from the Highlands of Scotland to the aristocratic houses of Italy, from post-Reformation England to the royalty of Catholic Spain. By conflating a host of non-classical peoples, the Goths had become the primal race: it was a vision that would have cheered Cassiodorus and Jordanes.

This renewed enthusiasm for the Gothic was reflected in a strand of religious humanism known as the *'translatio imperii ad Teutonicos'*—a second deliverance from the tyranny of Rome. The identification of classical Rome with Catholic Rome had developed in late antiquity. Once converted, the secular power of the Empire could be used to uphold the sacred authority of the church: in other words, the Roman Empire provided a readymade network that the early church could exploit, and the earthly city became a useful metaphor for the city of God. Christian rhetoric therefore shifted in the Middle Ages towards a centralized model based on Rome. In such a context, the Reformation could be read as divinely ordained: as the transfer of power to the Germanic peoples and an assertion of the true ancient church. Gothic moral integrity could once more be compared with Roman decadence, and the Reformation acquired an historical basis that in turn inspired further research.

Politics of ruin

The adaptability of the Gothic as a concept—or series of concepts—is evident in the political debates that dominated the Civil War crisis of the mid-seventeenth century, the Glorious Revolution of 1688 when William of Orange took the throne of Great Britain, and the 1707 Act of Union. 'Gothic' was the term used by Parliament to defend its prerogative against the absolutist tendencies of the monarch. As a national institution, it sought to justify its status historically, and thereby encouraged politically motivated antiquarian research. This is where the myths of vigorous, freedom-loving Goths were consolidated with the foundation of the English parliament. Through institutions such as the Saxon 'witenagemot' (the archetypal English parliament) described by Bede, both the Gothic spirit of liberty and democratic political representation became identified with the foundation of English government.

Everything rested on whether William the Conqueror was really a conqueror or not: was his Conquest absolute, or was his

government sanctioned by the Saxons? The Conquest was consequently redefined as an 'expulsion'. In *The Priviledges and Practice of Parliaments in England* (1628), for instance, the historian and antiquary Henry Spelman challenged the king's title to land over that of common law, which had a basis in Saxon rights. The ultimate consequence of this was to challenge the king's authority. The term 'anti-Normanism' was first used in 1642 by John Hare in *St. Edward's Ghost or Anti-Normanisme*, which called for William's title of 'Conqueror' to be rescinded, the monarch to trace his authority to Edward the Confessor, and the language, law, and customs of the country be expunged of 'Normanisms'.

But it was through Nathaniel Bacon and the six editions of his *Historicall Discourse* (1647–1760) that the Goths became most firmly associated with constitutional freedoms and the politics of liberty. According to Bacon, no nation on earth can show 'so much of the ancient Gothique law as this Island hath'. He argued that Saxon rulers were originally generals elected from a council of the nobility during times of war, and although this became an inherited monarchical position, the sovereign's power was established by consent of the people, and both were subject to the law. Describing the 'Saxon Commonwealth', Bacon proposes that, 'Afar off it seems a Monarchy, but in approach discovers more of a Democracy'.

The reason for Bacon's emphasis on balancing the estates of government was to prevent Gothic precedents being used to justify republicanism, as was subsequently argued by radicals such as the Levellers, or equally to admit that the Norman invasion was year zero in being an assertion of the absolute power of the king. Bacon points out that William of Normandy was crowned in accordance with Saxon ceremony, took the Saxon coronation oath, and established his government on Saxon principles—as a witenagemot. In other words, William had accepted the responsibilities and duties of a Saxon monarch, and so royalist attempts to extend the

power of the crown had no basis in law or history: they were unconstitutional and even treasonable. John Sadler's *Rights of the Kingdom* (1649) was another early nationalist work that presented the Saxons as the political fathers of English democracy, arguing that the House of Lords had a judiciary authority and the Commons legislative power. The balance of sovereignty and democracy was the defining element of Gothic politics here.

Despite his dismissal of the savagery and immorality of ancient Britons and Saxons in his *History of Britain* (c.1649), John Milton's *Defence of the People of England* (c.1650) also argues that Saxon witenagemots were parliaments in all but name, explaining that the word meant 'counsels of wise men'. Milton was however concerned to qualify his Gothicism with his Puritan belief in the Elect and the Reprobate: Parliament should (or at least could) be a congregation of the Elect. He therefore stresses the difference between the two Gothic lineages: on the one hand, the political inheritance of parliamentary representation, and on the other, the racial pedigree of freedom-loving Goths. For Milton, liberty must be responsibly exercised: it is not an endorsement of unregulated licentiousness.

Such historical theory underpinned Parliamentarian thinking, and for Charles I the road to the executioner's block was effectively paved with Gothic rhetoric. Within a few years these debates were revived when the Stuart dynasty, newly restored to the throne, also threatened to renew their Catholic sympathies and with them their absolutist tendencies. One commentator, Henry Care, responded by reprinting the Magna Carta in his *English Liberties: or, The Free-Born Subject's Inheritance* (1682).

By the time the Stuarts had been deposed in favour of the Protestant William of Orange, Gothic parliamentary rhetoric was firmly associated with the Whigs. Robert Molesworth identified the 'Ancient Form of Government' retained in England as Gothic (1694). James Tyrrell, making extensive use of Tacitus and Jordanes, likewise identified the Saxons as Goths 'with all the rest

of those Northern People'. This pan-Gothicism was confirmed by Molesworth, who later translated François Hotman's *Franco-Gallia* (1711), the central text in the French revival of German antiquity and its related democratic politics. In his Preface, Molesworth observed that: 'My Notion of a *Whig* ... is, That he is one who is exactly for keeping up to the Strictness of the true old *Gothick Constitution*, under the *Three Estates* of *King* (or *Queen*) *Lords* and *Commons*'.

Climate and the environment more broadly were still considered primary determinants of national character in seventeenth- and eighteenth-century racial theory, which meant that the weather was re-enlisted into the Gothic ideology. In other words, the English weather was viewed as an aspect of the Gothic temper of the country. In the *Character of a Trimmer* (1688), Lord Halifax described the spirit of compromise that characterized the progress of the English church and constitution—between Catholicism and Puritanism, absolutism and republicanism. This quality of 'trimming' between extremes (later called 'Gothic balance') was applied to every aspect of life. The wind and the rain of England were therefore in perfect accord with the Gothic temperament since it displayed none of the tyrannical meteorological excesses of arid deserts or frozen wastes: 'our climate is a Trimmer, between that part of the world where men are roasted, and the other where they are frozen'.

'Of poetry'

Attention was not solely focused on the Goths as a historical force in establishing variously Christianity and parliamentary government. Their culture was also a product of the same instincts of liberty and fertility, and so once settled, these characteristics were expressed in arts as much as in politics. The writers Roger Ascham, Samuel Daniel, and John Dryden, among others, all attributed the introduction of rhyming couplets in Romance verse (Italian, Spanish, French, and English) to the

pollution of Roman Latin by Gothic and Vandal languages. Dryden was pointedly unsympathetic to the impact of Gothic on classical tongues:

> Rome raised not art, but barely kept alive,
> And with old Greece, unequally did strive:
> Till Goths and Vandals, a rude northern race
> Did all the matchless monuments deface.

Others were rather more positive. Sir William Temple, probably the most influential Gothic literary theorist of the age, assessed the cultural implications of the Gothic in his essay 'Of Poetry'. While Temple's presentation of the Goths marks him as a Whig—Protestant and Parliamentary, in complete accord with the historical destiny of the ancient northern peoples—he also pondered why the seismic Gothic inundations and migrations should have ceased, and to what end their liberal instincts were then directed. He attributes the change to Christianity, which slowed down population growth by ending the mythical fertility of the Goths ('early and undistinguish'd Copulation'), and simultaneously fostered learning and civility. Gothic literature at this stage meant the sorcery of the Runers: Runic poetry, verses characterized by unrestrained flights of fancy. Failing to compose true poetry, they turned to enchantment and incantation, 'pretending by them to raise Storms, to calm the Seas, to cause Terror in their Enemies, to transport themselves in the Air, to conjure Spirits, to cure Diseases, and stanch bleeding Wounds, to make Women kind or easy, and Men hard or invulnerable'. Temple particularly relishes these supernatural elements as the first examples of witchcraft:

> *Mara* in old *Runick* was a *Goblin* that seized upon Men asleep in their Beds, and took from them all Speech and Motion. Old *Nicka* was a Sprite that came to strangle People who fell into the Water: *Bo* was a fierce *Gothick* Captain, Son of *Odin*, whose name was

> used by his Soldiers when they would fright or surprize their
> Enemies.

From this Gothic imagination, or '*Gothick* Wit', therefore 'may be derived, all the visionary Tribe of *Fairies*, *Elves*, and *Goblins*, of *Sprites* and of *Bulbeggars*', as well as mediaeval Romances, old English ballads, and Revenge Tragedy.

'*Gothick* Wit' began to saturate English (and British) culture in the period. According to Temple, fair trial by a jury of twelve of one's peers was Gothic in origin, and consequently favoured by both the Saxons and the Normans, both of whom could boast Gothic ancestry. He also argued in his essay 'Of Heroick Virtue' that the Goths, as the bravest of the ancient races, led them to develop the mediaeval codes of chivalry, heraldic motifs, and a battlefield culture of tilts and tournaments. This aspect of Gothic manners—mediaeval jousting—was derived from Tacitus' account of trial by combat, but it also connected with contemporary activities. It meant that hunting and dueling were chivalric and even Christian, as well as being proudly Gothic. And for the more sedentary, the martial Gothic spirit could be played out from the safety of one's armchair: chess, as a game of strategy, was described as a '*Gothick* Game'. Similarly, the suggestion that chivalry was the root of modern social manners and hospitality was reflected in the claims made for the Gothic regard of women, whom they involved in communal decision-making, and their insistence on monogamy among the tribes. The respect of the Goths for their womenfolk was in sharp contrast to the promiscuity of the Restoration court of Charles II.

So, despite entrenched Renaissance prejudices against the barbarism of the Middle Ages, antiquarian research and political theory became increasingly focused on the histories of late antiquity, the rise of the English Church, and the limitations of mediaeval sovereignty. At the same time popular culture had developed a taste for death and the supernatural in ballads and on

the stage, interest in chivalric romances was reviving, and critics were increasingly investigating the origins of English literature. These were wildly disparate threads. Yet within a century they had been woven together to create the textual fabric of the Gothic novels of the late eighteenth century. The next two chapters will look in detail at that period and the genesis of Gothic fiction.

Chapter 6
Gothic Whiggery

Eighteenth-century Britain embraced the Gothic. John Hare had praised English Teutonism as early as 1647, insisting, 'We are a member of the Teutonick nation, and descended out of Germany, a descent so honourable and happy, if duly considered, as that the like could not have been fetched from any other part of Europe, nor scarce of the universe.' This Teutonism seemed literally to come to pass in 1714 when the Hanoverian succession installed a German dynasty on the throne. It was a declaration of Gothic majesty. In politics, architecture, and literature, Gothic claims and counter-claims, theory and practice, provided a perpetual commentary. It was the means by which present issues could be placed in historical contexts, and proved to be a resilient instrument in making sense of the new country of Great Britain following the 1707 Act of Union.

Unionist Goths

The dispersal of the Goths was in one way analogous to the scattering of the Tribes of Israel, and so Gothic genealogies were recruited to contemporary politics as a way to reunite this heritage. Unionist rhetoric identified that the shared Gothicism of the English and the Scots mooted by Camden was an argument for the Act. *A Perswasive to the Union Now On Foot* (1706), for

example, put the case as straightforwardly as possible: 'If the *Goths*, of whom, as it's said, the *English* are partly come, be *Scythians*, and that the *Scythians* are *Scots*, then in common consequence the *Scots* and *English* must have the same Original, and been at first one People; and if so, it is no wonder, that after they were severed they should be so desirous now to unite.'

There were also wider political implications in this shared descent. The characteristic 'Gothick Constitution' discussed so energetically in the seventeenth century as a form of government that embodied natural rights of freedom and was inimical to tyranny and absolutism, appealed strongly to Whigs and Nonconformists. It gave them a voice in the newly forged Britain: hence in *Jure Divino* (1706) Daniel Defoe presents the '*Gothick* rules of Government' as a manifestation of natural order and human rights over absolutism. Gothicism was moreover adapted to the mercantile concerns of contemporary Whigs. This commercial dimension was introduced into the Gothic constitutional model by the political economist Charles Davenant, who argued that the Goths had an 'Original Compact among 'em'. They did not blindly follow their leaders, but engaged in political enterprises in return for shares in land and government. 'Gothick polity' was therefore characterized not only by parliamentary representation, but by feudal land management. By the 1740s, the claim that the British political system had Gothic foundations was a commonplace: 'It is to the *Gothick* Constitution that we owe our Parliaments, which are the Guardians of our Rights and Liberties'.

The material evidence of native Gothicism was all over the place in the remains of abbeys and monasteries that littered the British countryside after the Reformation, and gradually these ruins became sites of poetic reflection on the union. England and Scotland shared a common history in the Reformation (the Scottish Reformation occurring in 1560), and so these ruins served increasingly as the focus for historical meditation. In particular the school of melancholy—David Mallet's *The*

Excursion (1726), Mark Akenside's *Pleasures of the Imagination* (1744), Edward Young's *Night Thoughts* (1744–5), and the 'graveyard' poetry of Robert Blair—was obsessed by the sublimity of the past, how it dwarfed individual consciousness. Similarly, later poets such as Thomas Gray, who searched for inspiration in British history, found themselves burdened with the cruelty and brutality that stirred just beneath the surface of recent national events. In Gray's 'Bard' (1757), then, there is a morbid fascination with the savagery of political nation-building as English progress is perpetuated by the annihilation of Welsh culture. The English constitution that had apparently progressed by resisting absolutism, by increasing liberties and rights, and by avoiding extremism, had in fact within a few generations condoned regicide (the execution of Charles I), civil war, the invasion of William of Orange and the so-called 'Bloodless Revolution', and the systematic repression and execution of Irish, Welsh, and Scottish rebels such as at Glencoe (1692) and the Battle of Culloden (1746), culminating in the mass extermination of Jacobite sympathizers by the notorious Duke of Cumberland—'Butcher' Cumberland.

A second effect of aestheticizing the ruins that resulted from the devastation of the Reformation was that they became associated with other ancient remains. The original Goths had laid waste to Rome and its empire but had hardly left much behind them compared with Roman roads, amphitheatres, villas, and bath houses. The only non-Roman traces that survived from this period of ancient history were burial mounds and barrows, standing stones and stone circles—enigmatic monuments intimately associated with death, whether as tombs or, as was popularly imagined, as temples of sacrifice. These remains captured the imagination of Edmund Burke, among others. Burke devoted a chapter to the sublime effect of Stonehenge and the 'immense force necessary for such a work' in his *Philosophical Enquiry into the Origin of our Ideas of the Sublime and Beautiful* (1757). They were also recruited to William Stukeley's archaeological studies. In *Abury* ('Avebury', 1743), for example, he presented the Druids

as practicing an early and pure (that is, non-Roman-Catholic) form of Christianity. Druids, bards, and ancient Britons were the true Gothic Christians. Ancient monuments and Reformation ruins were again elided.

The first recorded architectural use of the word 'Gothic' in English had come in John Evelyn's diary for *c*.24–7 August 1641, and by 1708 Gilbert Burnet, Bishop of Salisbury, was explicitly associating the Gothic style with the Goths and Vandals, the Normans, and mediaeval cathedrals—in short, with non-classical taste. In effect this produced a continuous Gothic architectural history of Great Britain, running from megaliths to cathedrals. Both sets of monuments seemed to unite Britain: the ancient stones were a shared archaeological feature across the British Isles, and the Churches of both England and Scotland had a common heritage in splitting from the papacy. A significant further implication was to compound the Gothic both with mediaeval architectural styles and also with the subsequent destruction of those buildings—in other words, the raising and the razing of these vast edifices were seen as equally Gothic acts.

The Goth in the garden

All this intellectual fascination for Gothicisim was not simply theoretical: it had material consequences. The first Gothic garden building in Europe was built 1716–17 in Shotover Park for the Whig historian James Tyrrell (see Figure 5). The project was inspired in part by the defeat of the 1715 Jacobite rebellion, and similar Gothic follies were erected following the final defeat of the Jacobites at Culloden in 1746: one such was explicitly called the Culloden Tower (built for John Yorke at Richmond, Yorkshire), and Cumberland built his own Gothic tower and Gothicized Cumberland Lodge at Windsor following his bloodthirsty victory. The fashion spread rapidly and other Gothic towers were built to commemorate earlier triumphs of the spirit of liberty. Radway Tower was built at Edgehill (1746–7), scene of the first battle of the

5. The Gothic Temple, Shotover Park, Oxfordshire (1716–17): a neat, ironically almost Palladian, composition of pointed arches, ribbed vaulting, crenellations, and turrets, symmetrically focused on a rose window and finial

Civil War, and included fake ruins in its design. A year later the similarly ruined Hagley Castle (1748) was erected in order to evoke the Barons' Wars of 1263–7. It was the beginning of a more antagonistic and militaristic form of Gothic national identity.

There were no mediaeval garden houses to act as templates, so Gothic architectural style was abstracted into components such as arches, tracery, and pinnacles, which were reworked as an exterior décor that could summon up the past. The emerging fashion was predominantly Whiggish. Gothic garden constructions could embody the whole struggle for national political liberty—seen most strikingly in the Temple of Liberty (1741) built at Stowe for Richard Temple, Viscount Cobham. This construction combined a thousand years of Gothic attitudes: from monuments to Saxon deities to pointed arches, pinnacles, and a tower, all sealed with the mock-heraldic and supremely anti-classical motto, 'I thank God that I am not a Roman'. Even such minor features as crenellated ramparts were a reminder of the recent conflicts that had re-established the Gothic ideology at the heart of the constitutional monarchy: the Civil War and the Jacobite Rebellions.

In response to this Whiggification of English history and architecture, some Tories responded in like manner by building their own Gothic garden houses alluding to their own ranks of British Worthies, enlisting King Alfred and even King Arthur to their political and cultural cause. Two of the earliest eighteenth-century Gothic buildings constructed were Tory projects, what has been called 'Jacobite Gothick'. Alfred's Hall (Cirencester Park), the first ruined garden folly to be built, and Stainborough Castle (Wentworth Castle), a supposed restoration on the site of an Iron Age fort, both date from the 1720s and attempted to capitalize on Elizabeth and William Elstob's crypto-Jacobite account of the Anglo-Saxons, which described the original English as being passive and obedient to their sovereigns rather than pursuing 'the deposing Doctrine'. The proponents of this Tory Anglo-Saxonism believed that had more Anglo-Saxon mettle been shown in 1688, James II would not have been dethroned and the Stuarts would still be in power. Alfred the Great, the king renowned for driving out the Danes and therefore an English hero less immediately Gothic than his predecessors, was still being commemorated forty

years later by the Tory banker Henry Hoare, who built Alfred's Tower at Stourhead in 1762, although by then 'Jacobite Gothick' had really been and gone.

The rage for ruins spread across the country. They became a feature of the English landscape—extending the principle of property into the past and naturalizing land-owning. These building activities were not only sponsored by the commercial profits of the Whig plutocracy, but embedded their values in the very soil. English landscape gardening was also much favoured by Whig grandees. Patches of wildness were permitted to flourish amidst the geometric classicism that had dominated the previous century: paths began to meander rather than follow straight lines, trees were planted in clumps instead of rows, formal whimsies such as fountains and knot gardens were rejected in favour of waterfalls and rockeries. Gothic gardening also reclaimed one of the pejorative meanings of the Gothic: that it was 'rustic'. In 1722, the anonymous 'Cynick Philosopher' had described an extraordinary encounter with one of the inhabitants of Yorkshire: 'a strange Creature, wonderfully *Goth'd*, and be *Vandall'd*, even to Barbarity itself...a Beast of the Herd in Humane Shape'. Gothic gardening, informed by the revival of pastoral poetry and the cult of the picturesque, made a virtue of such rural roughness. Indeed, it became charmingly English. By the end of the century, the landscape architect Humphry Repton could remark that the English garden was 'the happy medium betwixt the liberty of savages, and the restraint of art; in the same manner as the English constitution is the happy medium betwixt the wildness of nature and the stiffness of despotic government'.

As Gothicism crept into gardens in the shape of uncultivated patches of 'natural' wildness, and into picturesque views as mock ruins, there were changes in the design of country houses too. Palladianism, the modish neo-classical standard for country houses, was increasingly superseded by the Gothic. This Gothicism began as a cosmetic style of arched windows and

ramparts installed in classical edifices, but it gradually became
more integrated and by the next century was constructional. Two
strands of revived Gothic architecture were proposed by the
architect Batty Langley in 1734: ancient and modern. Ancient
Gothic was 'massive, heavy, and coarse'—in effect everything
non-classical, from cumbrous megaliths and stone circles to squat
Norman churches and castles. Modern Gothic, however, was
'light, delicate, and rich to Excess', characterized by an 'Abundance
of little, whimsical, wild, and chimerical Ornaments': this was
high mediaeval architecture—prime examples being Westminster
Abbey and Lichfield Cathedral. Neither was at all classical.

This opposition between Gothic and classical architecture was
constantly stressed: they were styles, traditions, values perpetually
at odds, and indeed they received their meaning in part from this
perpetual contrast. As early as 1739, a correspondent to the
Gentleman's Magazine noted:

> Methinks there was something respectable in those old hospitable
> Gothick halls, hung round with the Helmets, Breast-Plates, and
> Swords of our Ancestors; I entered them with a Constitutional Sort of
> Reverence and look'd upon those arms with Gratitude, as the Terror of
> former Ministers and the Check of Kings. Nay, I even imagin'd that I
> here saw some of those good Swords, that had procur'd the
> Confirmation of Magna Charta, and humbled Spencers and
> Gavestons. And when I see these thrown by to make Way for tawdry
> Gilding and Carving, I can't help considering such an Alteration as
> ominous even to our Constitution. Our old Gothick Constitution had
> a noble Strength and Simplicity in it, which was well enough
> represented by the bold Arches and the solid Pillars of the Edifices of
> those Days. And I have not observed that the modern Refinements in
> either have in the least added to their Strength and Solidity.

This is the language of political progress, what would become in
nineteenth century the 'Whig' theory of history: the trinity of
Liberalism, Protestantism, and Progress.

By the 1750s, then, the architectural Gothic revival—or reinvention—was well under way. There were at the time just a handful of Gothic country houses constructed in Wales and Ireland, and none in Scotland, and neither did mainland Europe adopt the fashion save in scattered instances in Germany and France. But hundreds of Gothic houses were built or remodelled in England in a style most fully realized in Horace Walpole's rambling mansion, Strawberry Hill. Thousands more incorporated minor Gothic elements into the fabric of their domestic life inspired by the building manuals of Langley and his competitors, which featured a cornucopia of Gothic designs. Furthermore, interiors could be furnished with the most fashionable Gothic items: the master cabinetmaker Thomas Chippendale, for example, specialized in domestic Gothic taste, producing Gothic chairs, Gothic beds, and other indispensable Gothic furniture.

All this was too much for some. According to the Tory playwright and later Poet Laureate William Whitehead:

> A few years ago everything was Gothic; our houses, our beds, our book-cases, and our couches, were all copied from some parts or other of our old cathedrals This, however odd it might seem, and however unworthy of the name of Taste, was cultivated, was admired and still has its professors in different parts of England. There is something, they say, in it congenial to our old Gothic constitution, which allows everyone the privilege of playing the fool, and of making himself ridiculous in whatever way he pleases.

Whitehead's attempt to write the obituary of the Gothic and thereby damn the Whigs was, however, by any reckoning fatally premature. By 1753, when Whitehead made his complaint, the Gothic revival had barely begun.

Gothic letters

The Gothic was increasingly seen to embody an indigenous, recognizable English culture, and that culture encompassed

literature. Early examples of eighteenth-century Gothic literature are often therefore explicit comments on architectural and political Gothic. The anti-Jacobite novelist Henry Fielding, for instance, began chapter four of *Tom Jones* (1748) by praising the country pile of the Whig gentleman Squire Allworthy:

> THE Gothick Stile of Building could produce nothing nobler than Mr. *Allworthy*'s House. There was an Air of Grandeur in it, that struck you with Awe, and rival'd the Beauties of the best *Grecian* Architecture; and it was as commodious within, as venerable without.

Thomas Warton meanwhile described how the original 'Gothic state' of St Paul's was 'one of the noblest patterns of that kind of architecture' and argued that it had influenced Milton's poem 'Il Penseroso' (1754).

It is in Alexander Pope's 'The Temple of Fame' (1715), however, that the new Gothic architecture features most prominently. Pope's poem condenses cultural history into a material shape: an imaginary building aligned to the points of the compass. The four façades each represent a different region of civilization: the western Greek and Roman, the eastern Arabian and Asian, the southern Egyptian, and the northern Gothic. Pope, as a Catholic and Tory, designs the Gothic face as terrifyingly fierce, fabulous, and supernatural: bloodstained, decorated with figures of Druids and Bards and pagan gods, all 'O'er-wrought with Ornaments of barb'rous Pride'. It is also strangely distorted, the 'Wall in Lustre and Effect like Glass' magnifies and reflects the statuary work creating a dreamlike, uncanny—or 'Romantick'—effect.

Pope's inclusion of engraved Runic characters on the Gothic face of the Temple shows that Gothic literacy had become a commonplace by the beginning of the century. Indeed, Odin's Runes were considered comparable to the hieroglyphs of ancient Egypt in the development of written language. The 'Runers' who presided over this innovative writing system were consequently

acknowledged as the inaugurators of the legal convention of written laws, tying the inception of literature to Gothic polity. They were practitioners of the dark arts of both sorcery and politics: in *A Vindication of Stone-Heng Restored* (1725) John Webb described Gothic Runers as natural scientists, astronomers, and wizards who conversed with devils and saw into the future.

As for any linguistic survival of the Gothic language, it was popularly supposed that the harshness of 'stubborn Consonants' produced a '*Goth-like*' sound in native English names such as 'Hop' and 'Bubb'—rude and rustic names. Furthermore, in *The Tatler* (1710) there is an account of one 'Ned Softly', an English poet noted for his quirky stylistic inflections: 'the little *Gothick* Ornaments of Epigrammatical Conceits, Turns, Points, and Quibbles, which are so frequent in the most admired of our *English* Poets'. So just as Langley's modern Gothic architecture was distinguished by an abundance of ornamentation, English literature became associated with elaboration and quirkiness. Indeed, Joseph Addison, who despite being a Whig had no taste for Gothic, argued that the conceits of metaphysical poetry were precisely 'Gothic'. This native eccentricity is satirized in a spoof letter concocted by Jonathan Swift and published in *The Tatler* later in the same year. It is littered with breaks, abbreviations, and elisions 'directly contrary to the Example of the *Greeks* and *Romans*, altogether of the *Gothick* Strain':

> I *Cou'd n't* get the Things you sent for all *about Town* - - - - I *thôt* to *ha' come down my self and then I'd h' brôt'um; but I ha'n't don't, and I believe I can't d't*, that's *Pozz* - - The *Jacks* and others of that *Kidney* are very *uppish*, and *alert upon't*, as you may see by their *Phizz's* - - - - -

This is Gothic literature, but not as we know it. For that, it is necessary to examine in detail the 1760s—a decade in which the complexities and contradictions that were held within the meanings of Gothic coalesced into fiction.

Chapter 7
The sixties

Between the seventeenth and eighteenth centuries, the Gothic developed into three main strands: a political theory central to Whig interests, a burgeoning interest in mediaeval manners and their influence on national identity, and a cultural aesthetic that associated decay, nostalgia, melancholy, mortality, and death with the ancient Northern past. In different ways, the Gothic gradually permeated every aspect of cultural and social life: from gardening to graveyard poetry, from fashionable architectural statements to the editing of old literature. The 1760s was the decade in which the Gothic synthesized these disparate elements into new forms from criticism and scholarship to fiction and forgery.

Warton and Hurd

Thomas Warton's two editions of *Observations on the Faerie Queene* (1754, 1762) and Richard Hurd's *Letters on Chivalry and Romance* (1762) were critical studies of Edmund Spenser's Arthurian epic *The Faerie Queene* that focused on historical context, making the literature of the past a concern of the present. Although Spenser was, like Geoffrey Chaucer, admired as a cornerstone of the English literary canon, neither Spenser nor Chaucer were read as avidly as more modern writers such as Dryden and Pope. Nevertheless, Spenser had gradually begun to

exercise a new influence on contemporary poetry, most notably in the works of the best-selling poet James Thomson. Thomson's *Castle of Indolence* (1748), a poem written in Spenserian metre, described the dreamy, allegorical roaming of a knight errant.

Spenser appealed because he appeared to be the last connection with romance: those mediaeval tales of fabulous beasts, sorcery, and chivalric derring-do. In other words, *The Faerie Queene* afforded a cultivated connection with the pre-Reformation tradition of Elfland. As Joseph Warton put it in his 'Ode to Fancy':

> Then lay me by the haunted stream
> Wrapt in some wild, poetic dream,
> In converse while methinks I rove
> With SPENSER thro' a fairy grove.

Spenser offered an indigenous model for poetry independent of the neo-classical imitation prevalent at the time.

Joseph Warton's brother, Thomas, developed this idea in his *Observations*. The book was written as an introduction to Elizabethan literature, describing *The Faerie Queene*'s debt to mediaeval romance and the otherwise unknown Arthurian epic by Thomas Malory, the *Morte Darthur* (1485), as well as identifying the political subtext of Spenser's poem and its celebration of the court of Elizabeth. The analysis demonstrated that literary inspiration was an expression of national identity rooted in legendary history, blending contemporary expressions of Protestantism and political freedom into an English epic. It was, in other words, Gothic.

Warton's reading was in direct contrast to the line taken by critics such as John Upton. Upton, who was preparing an edition of Spenser's poem, described its rhyme scheme as 'that tinkling sound of similar endings, which was brought into *Italy* by *Goths* and *Huns*'. His approach was to judge the English work by

comparing it with Homer, Hesiod, and Virgil. Upton took an impressively scholarly approach by identifying Spenser's models as properly Gothic: *i.e.* the culture described by Ammianus Marcellinus and Jordanes. In contrast, Warton presented Spenser as deriving the work not from Gothic history but mediaeval romance. He positioned the *Faerie Queene* as part of an organic history of English Gothicism, independent of classical influences:

> too many readers view the knights and damsels, the turnaments and enchantments of Spenser with modern eyes, never considering that the encounters of Chivalry subsisted in our author's age, as has been before hinted; that romances were then most eagerly and universally read; and that thus, Spenser from the fashion if his age, was naturally dispos'd to undertake a recital of chivalrous atchievements, and to become, in short, a ROMANTIC POET.

In the expanded second edition of his *Observations* Warton investigated further the culture of early modern England, including not only an account of the Dance of Death, but also a history of English architecture from before the Conquest to the Reformation. In this impressively informed and highly influential digression, Warton identified the Saracenic influence on the 'Gothic' style and divided the native tradition into different orders: Saxon, Gothic Saxon, Absolute Gothic, Ornamental Gothic, and Florid Gothic, which was how things stood until Rickman's model. For Warton, art and architecture were all part of the fabric of Spenser's vision. The analogy of literature to building was of course familiar: in 1715, John Hughes had warned against treating the *Faerie Queene* as neo-classical: 'to compare it… with the Models of Antiquity, wou'd be like drawing a Parallel between the *Roman* and the *Gothick* Architecture'.

Richard Hurd's series of essays, *Letters on Chivalry and Romance* (1762), was essentially an extended development of this architectural comparison. Hurd, basing his informal *Letters* on Warton's *Observations* and French mediaeval scholarship, aimed to

investigate the pervasive influence of mediaeval romance on the great English poets: Spenser, Shakespeare, and Milton. Shakespeare, for instance, 'is greater when he uses Gothic manners and machinery, than when he employs classical', the reason being that Gothic machinery is far more effective at producing sublime effects.

Hurd explained this by paralleling the cultural and artistic fecundity of ancient Greece with the excesses of mediaeval Europe. Both had created institutions of chivalry, as well as a literature of enchantment, so Hurd's strategy was to demonstrate that if the conditions and therefore expression of Gothic and classical art differed, they were nevertheless produced by a common cultural logic. For Hurd, then, the Gothic, like classical composition, is governed by rules—different rules admittedly, but rules nonetheless—giving a 'unity of *design*':

> When an architect examines a Gothic structure by Grecian rules, he finds nothing but deformity. But the Gothic architecture has it's [*sic*] own rules, by which when it comes to be examined, it is seen to have it's merit, as well as the Grecian. The question is not, which of the two is conducted in the simplest or truest taste: but, whether there be not sense and design in both, when scrutinized by the laws on which each is projected.

Samuel Johnson summed up these systematizing principles perfectly: 'Hurd, Sir, is one of a set of men who account for everything systematically; for instance, it has been a fashion to wear scarlet breeches; these men would tell you, that according to causes and effects, no other wear could at that time have been chosen'. But Johnson disliked Hurd's theory of home-grown Gothic artistry for the same reasons that he disliked the faddish eccentricity of Laurence Sterne's *Tristram Shandy* (1759–67). In alarmingly different ways, the work of Hurd and Sterne installed the Gothic as a contemporary literary style. It is not surprising that Hurd concluded his *Letters* with a remark on the dominance

of Augustan reason by setting the agenda for a new advent of the
Goths:

> What we have gotten by this revolution, you will say, is a great deal
> of good sense. What we have lost, is a world of fine fabling...

It is to that 'world of fine fabling' that we now turn.

Walpole and Leland

Horace Walpole's *Anecdotes of Painting in England*, also first
published in 1762, afforded another reassessment of the Gothic.
Walpole's approach was not that of the system-builder Hurd, but
that of the connoisseur. He laments 'that destruction of ancient
monuments and gothic piles and painted glass' (the Reformation
and Civil Wars) on grounds of taste, considers Gothic architecture
as 'a species of modern elegance', and regrets that the names of
Gothic church builders have been lost: 'there is beauty, genius and
invention enough in their works to make one wish to know the
authors.' Most daringly, Walpole declares that, 'One must have
taste to be sensible of the beauties of Grecian architecture; one
only wants passions to feel Gothic....Gothic churches infuse
superstition; Grecian, admiration...'.

By the time he published the *Anecdotes*, Walpole was of course
living in his own monument to the eighteenth-century Gothic
revival: Strawberry Hill (see Figure 6). 'Strawberry', as he called it,
was first conceived in 1750—Walpole's ambition being 'to build a
little Gothic castle'. Strawberry was not based on the restoration or
extension of an earlier mediaeval building, neither was it located
on some historically hallowed site: it was simply a project to
Gothicize a cottage in Twickenham. Consequently, Strawberry
distanced Gothic architectural style from the specific contexts
promoted by more forthright Whiggery. It was sufficient unto
itself: a spectacle, a generalized performance of the English past.
Although Walpole did derive his designs from extant materials, he

6. Horace Walpole's Strawberry Hill, Twickenham—an architectural rhapsody composed by a Committee of Taste and performed as an elaborate reinvention of heritage. The most humble elements had venerable antiquarian pedigrees: the chimney piece in the Little Parlour was, for instance, based on the pre-Reformation tomb of Bishop Ruthall at Westminster Abbey

attacked earlier Gothic revivalists such as Batty Langley who had identified different orders of Gothic architecture on the model of the five Vitruvian orders of classical architecture. Walpole was aiming at an overwhelming aesthetic effect by collaging architectural fragments and the zealous pursuit of architectural asymmetry; he was not bothered by historical veracity.

The same year of 1762 also saw the first eighteenth-century Gothic novel: Thomas Leland's unjustly neglected *Longsword, Earl of Salisbury: An Historical Romance*. Set during the reign of Henry III (1216–75), *Longsword* is a neatly ordered narrative depicting the triumph of chivalry, honour, and good governance against perfidy, betrayal, and conspiracy. It is full of colourful incident and

period action: shipwreck, piracy, kidnapping, trial by combat, incarceration in castle dungeons, monastic intrigue, and attempted assassination. *Longsword* reads like an attempt to dramatize and exemplify Hurd's account of mediaeval values through the medium of a sentimental novel: it is effectively an illustrated conduct book of the Gothic virtues and a paean to national identity and 'the triumphs of British valour'.

In December 1764, Walpole's own Gothic novel was published: *The Castle of Otranto: A Gothic Story. Otranto* has of course been retrospectively constructed as the founding text of a new literary movement, and its magical mediaevalism has eclipsed the much more intricate set of associations that the Gothic had at the time. But *The Castle of Otranto*, while less Gothic than *Longsword* in many contemporary senses, was nevertheless a trailblazer and succeeded in shifting the entire Gothic paradigm. *Longsword* was a respectable success, yet *Otranto* became a modern classic: a second edition was demanded within months and there were at least ten editions by the end of the century.

Walpole was daringly experimental in his presentation of *Otranto*, claiming that it had been translated from an ancient copy discovered in a northern library. He was indebted to Shakespeare in language, style, and themes, and also to contemporary debates on authenticity and forgery—*Otranto*'s plot is based on fraud and inheritance, expressing perhaps a fear of the legitimacy of English Teutonism and the Gothic heritage. But Walpole's primary innovation was not in developing the elements already introduced by Leland by making the castles, crypts, secret passages, dynastic plots, mediaeval Catholic ritual, and latent violence ever more elaborate and labyrinthine: it was in the book's supernaturalism—the manifestation of a frightful (or farcical) colossus—and in allowing dreams to direct the action. Like *Hamlet*, experience is pervaded by dreams: 'do I dream?' ask both Manfred and Matilda. For an eighteenth-century readership, it was a revelation.

Walpole in fact claimed that the entire work was inspired by a dream, confessing to William Cole:

> I waked one morning in the beginning of last June from a dream, of which all I could recover was, that I had thought myself in an ancient castle (a very natural dream for a head filled like mine with Gothic story) and that on the uppermost bannister of a great staircase I saw a gigantic hand in armour … I was very glad to think of anything rather than politics.

The romance tradition is evident here, as is modern Gothic architecture and martial culture and even politics (both present and absent), all submerged into a dream. Dreams were supernatural, sublime, and dangerous. By using dreams Walpole was able to give voice and shape to the barely acknowledged suppression of history that hung behind the Gothic myth like a nightmare. The Gothic, far from being an antiquarian knot of history and politics, culture and society, could instead be a metaphor for the less tangible anxieties and traumas of the human condition.

Percy and Johnson

Within three months of *Otranto*, Thomas Percy published *Reliques of Ancient English Poetry* (1765). This was the first serious collection of old English songs and ballads, and in its lengthy supporting essays and headnotes proposed a theory of English minstrelsy that drew profoundly on Gothic sources.

Percy argued that mediaeval minstrels were the descendants of Gothic scalds (or bards), developing a poetic genealogy from Paul-Henri Mallet's account of ancient Scandinavia (*Introduction à l'histoire de Dannemarc*, 1755–6, translated by Percy as *Northern Antiquities*, 1770). Percy was in part responding to the sudden success of James Macpherson's *Ossianic* works (1760–5), which had redrawn the map of literary Britain by establishing the ancient Celtic bard Ossian at the head of the national tradition,

predating Chaucer by some thousand years. The Gothic heritage that Percy developed for native ballads justified them as remnants of an earlier epoch. The Goths were savage and vengeful, but also literate, 'in truth the most civilized of all the Northern nations of their time'. Consequently, as he explained to the Welsh antiquarian Evan Evans, the 'English reader' would recognize in their culture

> the seeds of our excellent Gothic constitution... many superstitions, opinions and prejudices... that the ideas of Chivalry were strongly rivetted in the minds of all the northern nations from the remotest ages... and... an ancient Islandic Romance that shews the original of that kind of writing which so long captivated all the nations of Europe.

Percy's Gothic theory was outlined in *Five Pieces of Runic Poetry* (1763), and expanded in the 'Essay on the Ancient English Minstrels', included in the *Reliques*. Percy argued by analogy, claiming, in Hurd's style, that the ferocity of scaldic society produced codes of chivalry. Consequently these scalds were the ancestors of the mediaeval English minstrels who produced the chivalric romances that had influenced Spenser, and the ballads on which Shakespeare drew—in support of which Percy included a sequence of ballads 'illustrating' Shakespeare: locating the sources that underpinned Shakespeare's Gothicism.

Until this point, criticism had tended to set Shakespeare above his age. Upton's *Critical Observations of Shakespeare* (1748) warned, '[w]e are little better than the sons of and successors of the Goths, ever and anon in danger of relapsing into our original barbarity'. The aim of such an approach was to remove Shakespeare from the entanglements of mediaeval romance, to make him independent of 'whatever is merely of a British and barbarous growth'. But Samuel Johnson's edition of Shakespeare (1765) was sufficiently informed by Warton's *Observations* and Percy's research to

present a historically based understanding of the English creative imagination.

Shakespeare was already the most quoted writer in Johnson's *Dictionary* (1755–6), a work which, despite Johnson's Tory politics, can be seen as a Gothic undertaking. Johnson explicitly states he wishes to recall English from its Gallic tendencies and return to a Teutonic model of language, recognizing its spirit of freedom: the English language is 'copious without order, and energetic without rules'. Similarly, in his prefatory essay to Shakespeare, Johnson applauds the 'naturalism' of Shakespeare, his lack of design, and his mingling of genre, and also criticizes (among many other things) Shakespeare's lack of moral purpose, his quibbling, and in fact his entire style: 'ungrammatical, perplexed, and obscure'. There is a hint of the Ned Softlys here in this condemnation, but Johnson has some sympathy with Shakespeare's disregard for dramatic unities: this rejection becomes Shakespeare's 'comprehensive genius'.

Johnson explains these idiosyncrasies by placing Shakespeare in a cultural context. When Shakespeare was writing, the taste of the English nation was mediaeval, 'struggling to emerge from barbarity', favouring 'adventures, giants, dragons, and enchantments': indeed, '*The Death of Arthur* was the favourite volume.' Shakespeare was therefore writing for an audience with a taste for romance, an audience that would recognize and value his 'Gothick mythology of fairies'. Johnson's assessment of Shakespeare, perhaps reluctantly, assigns him the liberal qualities of Gothic literary genius.

Chatterton and Rowley

By the 1760s, the Gothic described the Middle Ages, Elizabethan romance, mediaeval architecture, ancient Norse poetry, old English ballads, Arthurian romances, and Shakespeare, in addition to the

Germanic tribes and seeds of the English constitution. It is hardly surprising that Allan Ramsay made the candid observation in *A Dialogue on Taste* (1762, first published 1755) that 'the Goths were not so Gothic as they are generally imagined'. Moreover, in the hands of Warton, Hurd, Percy, and Johnson, the Gothic was also a determinedly English style. Catherine Macaulay's *History of England* (1763) reaffirmed Gothic Whiggery by detailing Anglo-Saxon liberties and the establishment of parliaments, and also appeared to provide evidence of a British identity united against Roman invaders. But this shift towards an inclusive British Gothicism was slow, and the writers of the 1760s stressed instead the particular English qualities of the Gothic.

Perhaps the most telling instance of 1760s Gothic is the poet Thomas Chatterton. His mediaeval writings were inspired by Spenser, Shakespeare, and balladry, and are suffused with the supernatural, from spirits to giants. His work is filled with antiquarian details, architectural sketches, and social history. He describes ancient English and provincial cultures rather than imported neo-classical and metropolitan taste, and presents the Whiggish values of commerce and the constitution as being inherent in the Middle Ages. Chatterton also attributed his mediaeval writings to Thomas Rowley, a fifteenth-century monk, and they have since been dismissed as forgeries. But his work can be more effectively read as a subtle challenge to the emerging discipline of contextual literary history—not least because Chatterton produced many of his works as manuscript artefacts (or, one might say, 'artefictions'). These 'found manuscripts' forced readers to acknowledge their relationship with the text by exposing the conventions of literary authenticity and its basis in documentary evidence, unreliable narrators, and editorial intervention. The debate surrounding the authenticity of the Rowley poetry conducted after Chatterton's untimely death gave significant momentum to the style of fiction exemplified by Walpole's *Castle of Otranto*. By the time the 'Rowley Controversy' had been settled, the Gothic novel had properly arrived.

Chapter 8
The descent into hell

Whether the poetic laurels (or perhaps ivy) should go to Walpole or to Leland for instigating the Gothic fiction, the effect was electric. The next century and a half saw a huge proliferation of Gothic novels, from the florid narratives of Ann Radcliffe to cheaply produced 'shilling shockers'. These works appealed particularly to the emerging markets of lower middle-class and female readerships who if they could not afford to purchase them could borrow the books from circulating libraries. The style was probably at the height of its popularity and innovation around 1810; thereafter it became increasingly sophisticated, producing such literary classics as *Frankenstein* (1818), *Strange Case of Dr Jekyll and Mr Hyde* (1886), and *Dracula* (1897). At the time, these books were known as 'romances', the 'German' style, 'novels addressed to the strong passions of wonder and terrour', 'hogoblin romance', '*hogobliana*', or, as Jane Austen put it in *Northanger Abbey*, 'horrid' novels—the term 'Gothic novel' was not used until the 1920s.

Whatever it was called, the style was however instantly recognizable and frequently parodied. An article on 'Terrorist Novel Writing' published in 1798, for example, gave a recipe for making a Gothic novel:

Take—An old castle, half of it ruinous.

A long gallery, with a great many doors, some secret ones.

Three murdered bodies, quite fresh.

As many skeletons, in chests and presses.

An old woman hanging by the neck; with her throat cut.

Assassins and desperadoes '*quant suff.*'

Noise, whispers, and groans, threescore at least.

Mix them together, in the form of three volumes to be taken at any
of the watering places, before going to bed.

The crucial activity of the Gothic imagination was seen as
inspiring terror and power, which was accomplished by creating
sublime effects based on Burke's *Philosophical Enquiry*. The
sublime signals the limits of rationality—the 'sleep' of reason—and
was best communicated by obscurity. So in the same spirit as the
recipes 'to make a romance', 'seven types of obscurity' could be
proposed for a Gothic novel:

1. meteorological (mists, clouds, wind, rain, storm, tempest, smoke,
 darkness, shadows, gloom);

2. topographical (impenetrable forests, inaccessible mountains,
 chasms, gorges, deserts, blasted heaths, icefields, the boundless
 ocean);

3. architectural (towers, prisons, castles covered in gargoyles and
 crenellations, abbeys and priories, tombs, crypts, dungeons, ruins,
 graveyards, mazes, secret passages, locked doors) (see Figure 7);

4. material (masks, veils, disguises, billowing curtains, suits of
 armour, tapestries);

5. textual (riddles, rumours, folklore, unreadable manuscripts and
 inscriptions, ellipses, broken texts, fragments, clotted language,
 polysyllabism, obscure dialect, inserted narratives, stories-within-
 stories);

6. spiritual (religious mystery, allegory and symbolism, Roman
 Catholic ritual, mysticism, freemasonry, magic and the occult,
 Satanism, witchcraft, summonings, damnation);

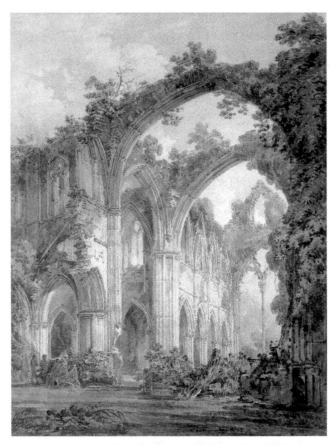

7. William Turner, *Inside of Tintern Abbey* (1794): the ruin of Tintern Abbey evoked the fallen majesty of the Middle Ages, the wreck of the Reformation, and the wilderness of nature. It became, in the hands of William Wordsworth, the sublime crucible of Romanticism

7. psychological (dreams, visions, hallucinations, drugs, sleep-walking, madness, split personalities, mistaken identities, doubles, derangement, ghostly presences, forgetfulness, death, hauntings).

All of these forms of obscurity—and readers will doubtless be able to suggest many others—aim at sublimity through mystification in order to probe the consequences of history and the telling of secrets.

Mediaevalism

Questions of racial migration and national identity lay behind the mediaevalist fashions that increasingly dominated the literary scene through Gothic novels. The Gothic literary style was either derived from the East (according to William Temple), from the North (according to Thomas Percy), or from a combination of the two (according to Thomas Warton). While all agreed that this early poetry was primitive or 'dithyrambic'—spontaneous and inspired, a form of enchantment—it was unclear what had originally stimulated it; perhaps it was the weather after all.

These theories of racial origin won immediate support from Johann Herder in Germany, who published two volumes of *Volkslieder* (1778–9) that inspired an era of ballad and folktale collecting. Herder argued that a shared national folklore could help to unify the German states. Likewise, the cousinhood of Gothic unity was also extended across Great Britain. John Pinkerton, a Scot, wrote in his essay 'On Fable and Romance' (1783) that 'remarkable in the Gothick nations, was an invincible spirit of liberty.... To them there is reason to believe that we are indebted for those two great establishments, which form the basis of British freedom.' So too in John Ogilvie's *Britannia* (1801), an ancient British Druid invokes Jordanes' image of the hive of nations:

I see the North
Pour forth like insects, her innumerous sons,
To heave th'unwieldy fabric from its base,
Of Roman greatness, rais'd through many an age!

By 1828, Sharon Turner, the first translator of *Beowulf*, could assert the Britishness of the Goths: 'our language, our government, and our laws, display our Gothic ancestors in every part'.

Edward Gibbon contributed to the debate with his *History of the Decline and Fall of the Roman Empire* (1776–89). The Goths were identified as the 'Gotones' of *Germania*, and Gibbon echoed Tacitus' opinion that Gothic vigour contrasted strikingly with Roman enervation and decadence. But although Gibbon celebrates Goths as 'that great people', they remained for him 'rude savages...destitute of a taste for the elegant arts'. Indeed, Gibbon mocks Jordanes' claim that the Huns were the foul offspring of witches and 'unclean spirits' as indicative of the credulity of the Goths:

> The tale, so full of horror and absurdity, was greedily embraced by the Goths; but while it gratified their hatred, it encreased their fear; since the posterity of daemons and witches might be supposed to inherit some share of the praeternatural powers, as well as the malignant temper, of their parents.

The comment was a timely reminder of the supernatural dimensions of the ancient Goths. James Beattie, author of *The Minstrel* (1771–4), described mediaeval feudal society in similar terms of supernatural dread:

> The castles of the greater barons, reared in a rude but grand style of architecture; full of dark and winding passages, of secret apartments, of long uninhabited galleries, and of chambers supposed to be haunted with spirits; and undermined by subterranean labyrinths as places of retreat in extreme danger; the howling of winds through the crevices of old Walls, and other dreary vacuities; the grating of heavy doors on rusty hinges of iron; the shrieking of bats, and the screaming of owls, and other creatures, that resort to desolate or half-inhabited buildings.

Hence the earliest Gothic novels adopted this style of the mediaeval infused with ancient spirits. Like *Otranto*, Clara Reeve's *The Old English Baron* (1777, 1778) was subtitled *A Gothic Story* and explicitly identified itself as Walpole's 'literary offspring'. Although it was set in England during the reign of Henry VI and could perhaps be said to have had more in common with Leland's *Longsword*, *The Baron* has a muted yet insistent supernaturalism: a haunted castle apartment and a plot activated by dreams. But what is particularly interesting about Reeve's case of inheritance and legitimacy is that the novel does not end on the revelation of murder and the restoration of hereditary rights and property, but devotes the last third of the narrative to ascertaining authenticity, unravelling legality, and securing dynastic lineage. It is a novel that voices contemporary anxieties about the historical basis of order and authority for the rising commercial middle classes and also in the challenges to British imperialism abroad—notably in the American colonies.

Historical romances remained popular throughout the period, particularly among Scottish and Irish writers. Scottish Gothic in particular tends to focus on the ancestry of the nation before and after the 1707 Act of Union, and the position of Scotland in the context of the British Empire (which was effectively run by the Scots during the eighteenth century). If Scottish Whigs could identify the same historical landmarks of progress as could the English Whigs, the situation north of the border was nevertheless dramatically complicated by the Jacobite rebellions, Highland Clearances, and *Ossian*. This recent history encouraged research into vernacular Scottish and Lowland culture: exemplified by Robert Burns and his reinvention of folk superstitions, and Walter Scott's translations of German supernatural ballads and his own collection *Minstrelsy of the Scottish Border* (1802–3), compiled with James Hogg. Scott's subsequent historical novels are explorations of unionism (even if the unionism is often suppressed) that consider the legitimacy of history and resist English Gothicization. Faced with the threat of being subsumed into Great Britian, Scott's

novels were in other words part of the same cultural identity formation as the invention of clan tartans—a way of reclaiming national ancestry and forging a fashion for the Celtic Fringe.

Revolution

There were also more immediate political issues that threatened Britain at this time: in 1789 the French Revolution began and the state prison of the Bastille was stormed on 14 July. Within four months the mediaeval fortress had been almost completely demolished, its masonry scattered across France as Republican souvenirs. The Revolution was therefore both a literal and figurative assault against the '*ancien régime*', the old order, and the response in Britain was consequently structured by Whig thinking about the English Gothic constitution. Most notably Edmund Burke, the theorist of the sublime, wrote *Reflections on the Revolution in France* (1790), an account that not only analysed but also dramatized the social collapse across The Channel as 'a drunken delirium from the hot spirit drawn out of the alembick of hell, in which France is now so furiously boiling...'. Burke's images of revolution are monstrous reminders that authority is vested in the body of the king: we 'look with horror on those children of their country who are prompt rashly to hack that aged parent in pieces, and put him into the kettle of magicians, in hopes that by their poisonous weeds, and wild incantations, they may regenerate the paternal constitution, and renovate their father's life.'

England already had the blood of one king on its hands, and the French Revolution was a painful reminder of the regicide on which Whig principles were based. Burke therefore emphasizes that the British constitutional model was founded on historical precedent and the hereditary descent of power and identity, as well as on Protestantism. The 'Glorious Revolution' of 1688 had been necessary but exceptional; it was driven by a 'firm but cautious and deliberate spirit'—the spirit of constitution of natural liberty and the balance of political forces. It was also a preservative revolution:

'The very idea of the fabrication of a new government, is enough to fill us with disgust and horror', particularly the invention of a 'geometrical and arithmetical constitution'. And of course it occurred under quite different historical conditions.

The historical state of the events in France was a decisive turn away from the past. In the most famous passage in the book, Burke laments the failure of mediaevalism in the treatment of Marie Antoinette:

> I thought ten thousand swords must have leaped from their scabbards to avenge even a look that threatened her with insult.— But the age of chivalry has gone.—That of sophisters, oeconomists, and calculators has succeeded; and the glory of Europe is extinguished for ever.

Such were the grounds of revolutionary debate in Britain. Thomas Paine responded in *The Rights of Man* (1791–2) that this was mere Quixotic nonsense, and Mary Wollstonecraft attacked chivalry as a vice in *A Vindication of the Rights of Woman* (1792).

The terror and the horror

It was at this time that according to Scott, Ann Radcliffe founded a new school of writing: 'She led the way in a peculiar style of composition, affecting powerfully the mind of the reader…appealing to those powerful and general sources of interest, latent sense and supernatural awe, and curiosity concerning whatever is hidden and mysterious'. Nathan Drake went so far as to call Radcliffe 'the Shakspeare of Romance Writers'. She was certainly the most highly paid novelist of the time by a very long way: Radcliffe received £800 for *The Italian*—over three times her husband's annual income—and is thus a central figure in the professionalization of female authorship.

Radcliffe's novels are typically Gothic. *The Mysteries of Udolpho* (1794) adopts *Otranto*'s setting of a castle as well as the theme of

inheritance, the debt to Shakespeare (again, *Hamlet* figures prominently), and an oppressive Catholic background. But Radcliffe's mode was, famously, the 'supernatural *explain'd*'. The process of reasoning rescues her protagonists. Although there is plenty of discussion about the existence of ghosts in *Udolpho* and the past keeps attempting to manifest itself in hauntings, those presumed dead have simply been hidden away. They return alive and well, not as revenants.

Although the Radcliffean focus on the female imagination, confinement, and madness has led her style of writing to be named 'Female Gothic', what is really female about Radcliffe's Gothic is that she draws on the eighteenth-century feminist intellectual tradition of the Bluestockings (such as Sarah Scott's novel *Millenium Hall*, 1762) and later educationalists such as Hannah More and Mary Wollstonecraft. Just as Reeve devotes a significant part of *The Baron* to unravelling the complexities of inheritance as if it were a case on trial, so Radcliffe accounts for every apparently supernatural aspect of her plots. This rationalist framework is also evident in later novels of the Female Gothic: even Mary Shelley's *Frankenstein* purports to have a scientific rather than an alchemical basis.

Radcliffe, then, rejects Gothic motifs even as she examines their effects. Gothic terror is for her a medium of the sublime—and in direct contrast to horror writing: 'where terror expands the soul and awakens the faculties to a higher degree of life, horror contracts, freezes, and nearly annihilates them'. Fears are therefore internalized and anticipated rather than actualized. William Gilpin described her vaguely allusive descriptive technique as 'sublimication', and Scott observed that in this, Radcliffe was indebted to Burke, making 'use of obscurity and suspense, the most fertile source, perhaps, of sublime emotion' and 'throwing the narrative into mystery, affording half intimations of veiled and secret horrors'.

Those very veils were however torn aside and the horrors laid bare in Matthew Lewis's *The Monk* (1796), a deliberate rewrite of

Radcliffe's *Udolpho*. This was sheer horror writing: violent, brutal, and sensational. Fears are horribly realized: characters are raped, murdered, and tortured. Supernatural forces are externalized: *The Monk* includes an animated corpse, demonic doubles, madness, live burial, and the Devil is summoned using a book of witchcraft. Lewis revels in excess and corruption—the aesthetics of decay in its most lurid physical, moral, and social forms—and perpetually eroticizes his narrative with a perverse sexuality of voyeurism and role-play.

Coleridge warned that if a parent saw *The Monk* 'in the hands of a son or daughter, he might reasonably turn pale'. The novel was seen as being particularly dangerous for female readers: one reviewer complained that 'A vein of obscenity...pervades and deforms the whole organisation of this novel...which renders the work totally unfit for general circulation.' The book was condemned—not least because Lewis was a Member of Parliament—and led to a debate on the morality of literature and the depiction of libertinism, blasphemy, and anarchy in literature.

Others welcomed it. The Marquis de Sade saw *The Monk* as an unflinching response to the Revolution:

> There was not a man alive who had not experienced in the short span of four or five years more misfortunes than the most celebrated novelist could portray in a century. Thus, to compose works of interest, one had to call upon the aid of hell itself, and to find in the world of make-believe things wherewith one was fully familiar merely by delving into man's daily life in this age of iron!

Lewis had read Sade's *Justine* in Paris in 1791, and Sade's revision of his own novel was in turn influenced by studying *The Monk*. But there is more to Sade's remark than mutual admiration. The French aristocracy and clergy were perceived to be hotbeds of

vice—heady cocktails of licentious carnality and absolute power. Hence revolutionary rhetoric was shot through with gross sexual imagery as a way of attacking these institutions: from scandalous depictions of Marie Antoinette to exhaustive accounts of the sodomitical activities behind the closed doors of monastic institutions. This rhetoric inflamed the mob, and was hideously played out in events such as the dreadful lynching of Princess de Lamballe in 1792. When in *The Monk* the prioress of the Convent of St Clare orders the execution of any nuns who have fallen to sexual temptation, the result is that incensed rioters destroy the Convent and exterminate the prioress. Her corpse is treated abominably: 'They beat it, trod upon it, and ill-used it, till it became nothing more than a mass of flesh, unsightly, shapeless, and disgusting.'

Sade's point is that desperate times require a desperate literature. The Gothic novels of 1790s' Britain can be seen as ways of addressing the carnage of the Revolution, and indeed William Hazlitt remarked of Radcliffe's precarious castles that they 'derived part of their interest, no doubt, from the supposed tottering state of all old structures at the time'. The French Revolution also stirred guilty memories of the regicide of Charles I and the founding of the Commonwealth 150 years previously. The past proved to be inescapable: English history had returned, and this return precipitated a crisis in national identity. This is apparent in Radcliffe as the mismatch between experience (supernatural terror) and reality (natural explanations). Order can be restored—but it is revealing that in her final novel, *The Italian* (1797), written in response to *The Monk*, Radcliffe does introduce unexplained supernatural elements into the narrative: reason, it appears, cannot account for everything. In Lewis, the same crisis is expressed as the mismatch between rational appearance and supernatural reality—events will inevitably return to haunt the perpetrator. But order is not restored: everything has now changed. And there is no redemption.

Chapter 9
The poetics of blood

Gothic novels deeply impressed a new generation later known as the Romantics—the very name revealing their perceived debt to the romances of the Middle Ages. Writers from Samuel Taylor Coleridge to John Keats, and artists from Henry Fuseli to Caspar David Friedrich shared a fascination with the sublime and the infinite, organicism, individual identity, rebellion, and of course the past. Fuseli's celebrated painting *The Nightmare*, for instance, became an iconic image of the age, imitated and adapted and parodied throughout the nineteenth century. Such Gothicism influenced the central writers of the period from the Brontë sisters to Charles Dickens to Oscar Wilde, as well as political theorists such as Thomas Carlyle and Karl Marx.

Romanticism

Gothic Romanticism is a vast subject: it runs from Percy Bysshe Shelley's Gothic novels *Irvyne* (1808–9) and *Zastrozzi* (1810) to Thomas Love Peacock's satires *Nightmare Abbey* (1818) and *Crotchet Castle* (1831), from the frightful tales published in the 'Maga' (*Blackwood's Edinburgh Magazine*, 1817–32) to the gentle mediaevalism of the Eglinton Tournament (1839) inspired by Charlie Lamb's colony of pet guinea pigs (for which he provided genealogies, armorial bearings, and a chronicle 'The Kingdom of

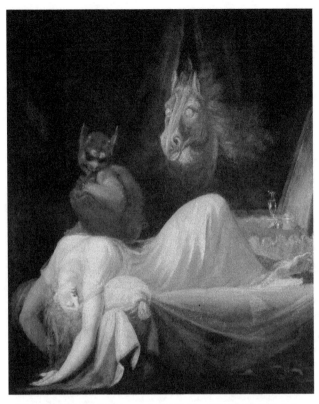

8. Henry Fuseli, *The Nightmare* (1790/1). Fuseli originally painted these supernatural beings as horridly corporeal (1781); in this later version they are more elusive and phantasmic—figures both foreboding and dreamlike, otherworldly, denizens of Faërie

Winnipeg'). All were immersed in the Gothic literary fashions of the time—aesthetically, politically, and parodically.

Initial momentum came from Germany. German writers and artists had responded to Herder's enthusiasm for *Volkslieder* by delving into folk and ballad traditions for legendary material,

abandoning classical literary conventions, and celebrating overreaching, Promethean genius written in an impulsive and declamatory style. It was thrilling stuff: in 1792 Coleridge wrote to Robert Southey on a translation of Friedrich Schiller's play *Die Räuber* (1781):

> My God! Southey! Who is this Schiller? This Convulsor of the
> Heart? Did he write his Tragedy amid the yelling of Fiends?

Among the many German plays translated into English in the 1790s, *Die Räuber* was one of the central works of the German '*Sturm und Drang*' (storm and stress) movement—a movement that had begun with a play on the American War of Independence by Friedrich Klinger (1777), reflecting issues of political legitimacy and national destiny.

German ballads also had a British audience—the most compelling being Gottfried Bürger's poem *Lenore*, derived from Percy's *Reliques*. The macabre tale combines the lover-revenant of the ballad tradition with the fatal inevitability of the Dance of Death. The undead lover is revealed to be Death himself, who putrefies before Leonora. In William Taylor's translation (1796):

> His head became a naked skull;
> Nor hair nor eyne had he:
> His body grew a skeleton,
> Whilome so blithe of ble.

> And at his dry and boney heel
> No spur was left to bee;
> And in his witherd hand you might
> The scythe and hourglass see

This appetite for the sensational seized Coleridge. By the time he wrote 'The Rime of the Ancyent Marinere' (1798), Coleridge was an expert in the field, writing in 1797 that he had been reviewing

The Monk and *The Italian* '& all the tribe of Horror and Mystery, have crowded on me—even to surfeiting'. The mesmeric tones of the doomed mariner, the demonic spirit that haunts their route, the sinister sea monsters that crawl upon the coagulated sea, the nightmarish galleon of Death and Life-in-Death, and the animated corpses that crew the ship all derive from 1790s Gothic.

The Gothic proved consistently adaptable to political uses as well. As Scott had developed a Unionist mediaevalism, so Charles Maturin (himself descended from Huguenots, or French Protestants) repositioned Gothic in an Irish context following the 1801 Act of Union between Great Britain and Ireland. In *Melmoth the Wanderer* (1820), the protagonist has made a pact with the Devil and is now 150 years old. History is therefore alive (or rather undead) in the story, but it is also digressive and unstable. The plot proceeds as a bewildering series of stories-within-stories that defeat attempts to make linear sense of the narrative, styles merge and overlap, and personalities, such as the 'eminent puritanical preacher', are split:

> He foams, he writhes, he gnashes his teeth; you would imagine him
> in the hell he was painting, and that the fire and brimstone he is so
> lavish of, were actually exhaling from his jaws. At night his *creed*
> *retaliates on him*; he believes himself one of the reprobates he has
> been all day denouncing, and curses god for the very decree he has
> all day been glorifying Him for.

Irish identity is fractured and crazed, and *Melmoth*'s snarled-up chronology reflects the Protestant Ascendancy trying to unravel Irish history. As a Calvinist surrounded by Catholics, Maturin revives the Protestant fears of Rome that lay deep in the Gothic imagination. In returning to its Reformation source, in studying persecution and exile, automatism and authority, and in drawing on images of cannibalism and immolation that had been part of Anglo-Irish rhetoric for a century (for example in Jonathan Swift's

scathing satires), *Melmoth the Wanderer* reinvented the Gothic as a nationalist trauma.

The influence of Irish-inflected Gothic can also be seen in the writings of the Brontë sisters, daughters of an Irish clergyman. In Emily Brontë's *Wuthering Heights* (1847), Ireland's position within the Union as uncomfortable and rebellious is reflected in Heathcliff's ambiguous position in the Earnshaw family. Heathcliff is a foundling: he has Faërie origins and is given the ghostly name of a dead child, but is never properly incorporated into the family. Yet Heathcliff does more than simply haunt English notions of family loyalty: by skilful manipulation he acquires the property of both the Earnshaws and the Lintons, overturning outdated class structures like some avenging demon of progress. He marries Isabella and fights with Edgar Linton, prompting Catherine's scorn against her genteel husband who mocks his social respectability with the Burkean observation: 'In old days this would earn you a knighthood!' Moreover, the novel does not simply dramatize Anglo-Irish conflict but suggests how national difference is made racial. Relationships between characters are structured as systems of bondage that revive memories of slavery (slavery in the British Empire was only abolished in 1834). Earnshaw's trip to the slave port of Liverpool in 1771 and his discovery of the young Heathcliff there consequently associates the boy with racial difference. It is not that Heathcliff is black, but that he disturbs the genealogical purity of class identity: the descent of the aristocracy. Hence he is treated as if he were black, and compared to a ghoul, a basilisk, a devil, and, most suggestively, a cannibal.

The hidden histories disclosed by the Gothic in the nineteenth century are therefore inflected by Unionism and race—both intimately linked to Whiggish commercial values and national identity. In Charlotte Brontë's *Jane Eyre* (1847), Bertha Mason, the mixed-race wife of Mr Rochester, is 'half dream, half reality'. Like Heathcliff, she is a creature of Faërie—a 'goblin'—and a demon sister to Jane who is herself called a 'malicious elf' and a 'sprite'.

Bertha exists in a drugged netherworld of dreams, imprisonment, and disguise. She is the nightmare of slavery, a dreadful colonial secret that can only be represented supernaturally by an oppressive logic that transforms the victim into the threat itself: 'the lips were swelled and dark; the brow furrowed: the black eyebrows widely raised over the bloodshot eyes'. She reminds Jane Eyre 'Of the foul German spectre—the vampire'.

Science

The century's obsession with vampires emerges from the Gothicization of science. Just as the Enlightenment's thirst for empirical understanding was made Gothic by the notion of forbidden or dangerous knowledge, so William Harvey's work on the circulation of the blood, discoveries in electricity, the fashion for craniology (phrenology), the effects of drugs, and Darwinian evolution all became Gothic—a particularly medical form of the Gothic.

The Monster in Mary Shelley's *Frankenstein* is the product of a laboratory where Victor eviscerates and joints bodies. Although Victor's researches begin in alchemy and magic (connecting him with the mediaeval world) they culminate in modern studies of anatomy and electricity, thus linking him to the latest scientific discoveries. The Monster is both alive and dead, stitched together from dead remains: a walking *memento mori*, on the threshold of life and death. Moreover the novel itself is made up of fragments of other books, including Milton's *Paradise Lost*, and the Monster internalizes all of this by being a keen reader himself. This Monster is a physical and intellectual reality, not a supernatural being, and the book aims at a visceral effect—according to Shelley it would 'curdle the blood and quicken the beatings of the heart'. Such corporeality is present in Shelley's other writings. The fragment 'The Fields of Fancy', for instance, describes the predatory carnivorousness of nature: 'If I thought of the creation I saw an eternal chain of evil linked one to the other... each

creature seems to exist through the misery of another & death & havoc is the watchword of the animated world—And Man also.'

Thomas Lovell Beddoes also dwelt upon the mysteries of anatomy and medicine, collecting skulls and studying craniology and anatomy. He presented his dramatic poetry as if it were an experiment in the physics of mortality, arguing that the studies 'of the dramatist & physician are closely, almost inseparably, allied; the application alone is different'. His central work, *Death's Jest Book* (commenced 1825), is a grimly morbid pantomime that anticipates Edgar Allan Poe's 'Masque of the Red Death': cynical, futile, careless of consequences. In this strange world pervaded by the madness and black humour of Elizabethan and Jacobean Revenge Tragedy, dreams become weirdly revelatory:

> A dream which eludes your recollection – like a rock in which some enchantress dwells which every now & then assumes the appearance of a portal machicolated & then again is barren rock.

There is no boundary between life and death in *Death's Jest Book*, and it is the sense of dreaming, the premonition of death, that becomes so bewitching—and beyond the comprehension of craniology. Dreams in Beddoes are portals that mark the edge of understanding, but yet provide an elusive hold on life.

The laureate of dreams in the century was Thomas De Quincey. For De Quincey, the anatomy of the brain was adapted to a dialogue with the infinite: 'the dreaming organ', he writes in 'Suspiria de Profundis' (1845), 'forces the sublime into the chambers of the human brain', and access to the sublime could be enhanced by taking opium. De Quincey developed many images that would later be adopted by psychoanalysts, such as mapping the mind as a palimpsest, and determining the personal significance of dream logic. He claimed his own dreams and

visions were structured like Gothic cathedrals or musical fugues: 'I seemed every night to descend—not metaphorically but literally to descend—into chasms and sunless abysses, depths below depths, from which it seemed hopeless that I could ever re-ascend'. As in Coleridge's writings, the sublime is intensified into a complete extinction of the self:

> Gothic art is sublime. On entering a cathedral, I am filled with devotion and awe; I am lost to the actualities that surround me and my whole being expands into the infinite; earth and air, nature and art, all well into eternity, and the only sensible expression left is, 'that I am nothing!'

According to De Quincey, then, opium inspired private Gothic experiences in an overwhelming mix of impressions and flashbacks: dizzying architecture, heraldry, labyrinthine urban spaces, *Paradise Lost*, alienation, idolatry, exile, incarceration, and underworld conspiracy. They were annihilating experiences.

But writing on opium is not, for De Quincey, about the super-natural. Rather it expresses a profound fear of consumption, and the attendant anxieties of contagion and contamination. The drug is a commodity that is dependent on trade and the empire, a product of European colonialism. Hence De Quincey's intoxicating passages on the Orient. He fears the response to imperialism, fears 'reverse-colonization' in which the 'other', whether as drug or an exotic being, invades and enslaves the British nation. The same fears are later expressed in *Dracula*: opium is, in other words, vampiric.

After De Quincey, drugs haunted Victorian literature from Wilkie Collins' *Woman in White* (1860) to, most stunningly, *Strange Case of Dr Jekyll and Mr Hyde* (1886). Robert Louis Stevenson's tale draws on the scientific claims of drug writing combined with Darwinist thinking to present a new way of imagining the

relationships between humans and animals—under the pervasive Scottish influence of James Hogg's *The Private Memoirs and Confessions of a Justified Sinner* (1824).

The text of Hogg's novel of demonic doubles and pursuit is found in a manuscript, the discovered document evoking the authenticity debate of *Ossian* (which quarrelled over competing Gothic and Celtic historical theories), and the relationship between Scottish and Unionist history: the *doppelgänger* can thus represent the split identity of Scotland and Britain. *Jekyll and Hyde*, however, is more complex. It is composed in a series of documents that draw attention to forensic detail and detection, and medicalizes the demon brother as the symptom of an impure drug. Like De Quincey's opium, the drug is an amoral foreign agent that provokes a transformation, but in Jekyll's case, the transformation back to reality from the 'horror of my other self' becomes increasingly difficult and ultimately, when the drug supply runs out, impossible.

By such sinister chemistry *Dr Jekyll and Mr Hyde* confronts evolution—Darwin's theory that biologically, humans are as rooted in the distant prehistoric past and no more moral than apes:

> He thought of Hyde, for all his energy of life, as something not only hellish but inorganic. This was the shocking thing: that the slime of the pit seemed to utter cries and voices; that the amorphous dust gesticulated and sinned; that what was dead, and had no shape, should usurp the office of life. And this again, that insurgent horror was knit closer to him than a wife, closer than an eye.

Evolution is two-way: it is possible to regress. In the context of Unionism, this regression (or transformation) can be read as Stevenson's inferiority complex as a Scotsman in English literature, about the lost Scottish heritage that fell at Culloden, and about a fatally divided Scottish identity between Lowlanders

and Highlanders. It is a question of racial ancestry: Hyde is the unspeakable Celtic alternative to an Anglicized Scotland.

Vampires

The vampire arrived in Britain in 1732 in a report from Hungary of '*dead Bodies* sucking, as it were, the Blood of the *Living*'. It rapidly became a political image of ravenous government ministers sucking the blood out of the people, even beyond the grave, and was a staple of travellers' tales of central Europe where local folklore could be connected to the ancient Scythian race. Coleridge and Keats both dealt in vampire literature, but the figure really came of age in 1819 in a novella conceived in Switzerland. One fateful night at the Villa Diodati, Lord Byron, the Shelleys, and their entourage held a competition to compose a ghost story. The stories that emerged were not however ghost stories: they were Mary Shelley's *Frankenstein* and John Polidori's 'The Vampyre'. Polidori recast the figure of the vampire: far from being a Hungarian peasant, Lord Ruthven 'the vampyre' was a sexual predator, powerfully attracted to the virtuous and the virginal. The character was based on Samuel Richardson's sadistic rake Lovelace, who raped Clarissa, and on Lord Byron. Everyone was delightedly scandalized.

Henceforth the vampire became cultured and wealthy, if not necessarily male. Coleridge's 'Christabel' (1816, commenced 1797) and Sheridan Le Fanu's later story 'Carmilla' (1872) both focus sharply on female vampirism and feminine desire. And while it is almost irresistibly tempting to see these female-on-female vampires as same-sex fantasies, they are actually voicing more direct anxieties about marriage, bourgeois social stability, and child-bearing. The female vampire exemplifies fears of the non-heterosexual reproduction of women—the literal rejection of mankind. As the criminologist Cesare Lombroso claimed in an 1896 account of prostitution, 'Woman being naturally and organically monogamous and frigid, love is for her a voluntary

slavery'. Such fears were actualized in the 'New Woman' of the mid-1890s: women who smoked, dressed casually, rode bicycles, educated themselves, and pursued careers, seemingly oblivious of spousal and maternal responsibilities.

Just as 'Christabel' and 'Carmilla' have been sexualized, so too has Christina Rossetti's poem 'Goblin Market' (1862). The fruits of the goblins are not just home-grown, but exotic produce: 'Citrons from the South'—in other words, 'Goblin Market' is another tale of Empire and international trade, of drugs domesticated as citrus fruits. Hence too the use of Gothic imagery by Karl Marx, who described capital as 'dead labour which, vampire-like, lives only by sucking living labour, and lives the more, the more it sucks'. Nineteenth-century vampire tales are essentially concerned with consumption, not sex. Sex in nineteenth-century vampire texts is merely a displaced lust, a metaphor for consumption and the commodification of human beings.

Bram Stoker's *Dracula* (1897) has been most vehemently over-sexualized but again is primarily a dissection of Victorian capitalism. When Lucy Westenra declares of her courtships 'Why can't they let a girl marry three men or as many as want her?' she is already half-vampire. The vampire is the arch-consumer:

> The fair girl went on her knees and bent over me, fairly gloating.
> There was a deliberate voluptuousness which was both thrilling and
> repulsive, and as she arched her neck she actually licked her lips
> like an animal, till I could see in the moonlight the moisture shining
> on her scarlet lips and on the red tongue as it lapped the white
> sharp teeth. Lower and lower went her head....I closed my eyes in a
> languorous ecstasy and waited – waited with beating heart.

Contemporary consumerism is apparent in the modernity of the novel. The latest communications media are central to the plot. *Dracula* Gothicizes technology: typewriting, train timetables, the phonograph, telegrams, and newspapers, as well as medicinal

drugs (sedatives and laudanum) and pioneering surgery (blood transfusions and brain operations). Occult machineries suffuse the book: radio communication, for instance, is as inexplicable as Mina's hysteria or Lucy's somnambulism or Renfield's bizarre premonitions. Indeed, Van Helsing comments, 'Let me tell you my friend that there are things done today in electrical science which would have been deemed unholy by the very men who discovered electricity—who would themselves not so long before have been burned as wizards'. Dracula himself is also a modern man. He has legal and commercial interests, is developing a property portfolio, and relies on international financial systems for his investments.

More generally, the novel is informed by challenging new ideas. In 1895 the criminal anthropologists Cesare Lombroso and Max Nordau published *The Man of Genius* and *Degeneration*, respectively, examining social deviants from criminals to homosexuals, New Women to Pre-Raphaelite artists. Degeneration reversed evolution, positing that humanity could regress to a bestial state, much as Dracula metamorphoses into a wolf. Such ideas also shaped H. G. Wells's *The Island of Dr Moreau* (1896), a peculiarly unnerving example of Gothic science, in which Dr Moreau, a vivisectionist, attempts to transform beasts into humans: 'Every time I dip a living creature into the bath of burning pain I say, "This time I will burn out all the animal; this time I will make a rational creature of my own!"' But inevitably, they revert: 'As soon as my hand is taken from them the beast begins to creep back, begins to assert itself again'.

Consumption, communications media, free-market capitalism, ecology, and vivisection form the Gothic fabric of *Dracula*, and so despite its folkloric elements it is a thoroughly up-to-date book. It is also a study of nationalism and British imperialism. Most of the Crew of Light have colonial experience, and the twin threats of migration and contagion clearly motivate the plot. Dracula's home is in Transylvania, at the centre of the 'Eastern Question'—the complex set of relations between East-European states that

became a diplomatic sideshow for the major European powers and which eventually precipitated the Great War in 1914. Transylvania was also arguably the homeland of the original Goths: Stoker calls it 'the whirlpool of European Races' and Van Helsing notes of the vampire that 'He have follow [*sic*] in the wake of the berserker Icelander, the devil-begotten Hun, the Slav, the Saxon, the Magyar'. Dracula himself claims to possess a proud bloodline and a long genealogy, but he is really a usurper, expropriating land and property—an omen of the end of civilization. Dracula articulates not only the terror of a past that refuses to die, but also the horror of modern technology that knows only how to consume.

Chapter 10
The Gothic dream

The Gothic Revival in architecture took much initial inspiration, as did literary Gothic Romanticism, from Horace Walpole: from both his fanciful castle in the air, *Otranto*, and from the extravagant realization of Strawberry Hill. Yet it evolved into a structurally sound theory for the built environment. And neither was this Revival confined to architectural projects: it encompassed a whole theory of social renewal. Consequently, the Gothic Revival universalized Whig notions of individual rights and freedom on the model of the British constitution. The Palace of Westminster (the seat of British government) was rebuilt as a symbolic declaration of constitutional identity through architecture—it was a Gothic Revival masterpiece structurally and decoratively, inside and out. The Revival was also miniaturized into home furnishings and interior décor to the extent that the Gothic became one of the cultural exports of the age in tables and chairs, wallpaper and curtains—as well as Gothic jewellery and, more soberly, Gothic graveyard monuments: the fashion for pointed-arch gravestones originated in this period. Taken in conjunction with the diverse elements of the Gothic imagination described in earlier chapters, this meant that during the Victorian period there was a magnificently prolific and often blatantly multifarious Gothic ethos.

Monasteries or castles?

The revival of Gothic architectural styles had already been well underway in the gardens and drawing rooms of eighteenth-century country houses, and Strawberry demonstrated that it could be a full-blown architectural possibility. The Strawberry style was monastic: mediaeval, cloistered, and sumptuous. It was a status symbol and indeed the preferred style of the new capitalists making fortunes from colonial trade and the industrial revolution. William Beckford, for example, a Gothic dilettante who had written the sensational orientalist Gothic fable *Vathek* (1786) and inherited an massive fortune derived from slavery, built Fonthill Abbey in Wiltshire (1796–1812). Fonthill was a fantastical creation, a sublime Romantic work of art. Its dimensions were vast, its perspectives almost infinite, and its spire was taller than that of Salisbury Cathedral. Beckford filled it with both authentic artefacts of the Middle Ages and whimsical Gothic knick-knackery, even making outrageous heraldic claims by deriving his family from the original Knights of the Garter and the six sons of Edward III. Fonthill collapsed in 1825, but by that time Beckford had already sold it and moved to Bath. Little now remains.

Castles, like ruined abbeys, dotted the British countryside and had strong associations with earlier struggles for liberty and the Whig notion of historical progress. They were rough in their design and masonry, often overgrown with ivy, and frequently—like ecclesiastical remains—decayed and naturalized to the landscape. Hence they were favourites of picturesque artists and designers who valued the roughness of nature, consistent with Gothic characteristics of organicism. But power and ownership were inscribed here too: Humphry Repton argued in *Sketches and Hints on Landscape* (1795) that these houses showed the 'unity and continuity of unmixed [inherited] property' of the landowning dynasty. He explicitly—and approvingly—described this aesthetic as 'appropriation': it was a reminder of the traditional values of deference and paternalism.

But despite being impressive statements of identity, there were practical problems in adapting monastic and castellar designs to the requirements of nineteenth-century life: clients demanded social spaces and guest rooms, not to mention modern heating, plumbing, and sanitation. Repton had pointedly observed in 1799 that Castle Gothic was 'calculated for a prison', and he inaugurated Tudor Gothic as an amenable solution. This was a Manor House style that evoked the golden age of Elizabethan England and Jacobean Scotland ('Jacobethan')—most spectacularly seen in the sixteenth- and seventeenth-century detail of Walter Scott's home, Abbotsford. There was a market for building manuals, the most significant being the *Encyclopaedia of Cottage, Farm and Villa Architecture and Furniture* (1833) by John Claudius Loudon, compiled with help from his wife Jane, author of the futurist Gothic novel *The Mummy!* (1827). It was a catalogue of lancet windows, gabled porches, exposed timbering, battlements, and domestic floor plans.

Although all of these buildings were, like Strawberry, confections, a growing library of antiquarian county histories was unearthing masses of historical architectural detail, and this enabled Thomas Rickman to update the orders of Gothic architecture proposed by Batty Langley and later by Thomas Warton into handy new categories. After Rickman's *Attempt to Discriminate the Styles of English Architecture from the Conquest to the Reformation* (1812–17; see Chapter 2) buildings became more structurally informed and less picturesque. Decoration once again had a structural basis: rather than being superficial it was now integral, and so the aesthetic of a building was reunited with its physical construction. And with this came the understanding that the great cathedrals and abbeys were at the centre of mediaeval communities, not only symbolically but also socially.

Gothic became the national style. One hundred and seventy out of the 214 churches built by the Church Building Commission (established 1818) were Gothic. At Cambridge University, new

Gothic architecture linked the scholarship of the present to the learning of the mediaeval past, and was also a religious and ideological reaction to the scientific rationalism of thinkers like Tom Paine and Jeremy Bentham. (In contrast, when the University of London was founded in 1826 on a non-religious basis it utilized neo-classical architecture.) Schools and libraries likewise adopted the style, linking associations of knowledge and piety, tradition and authority.

Castellar Gothic dominated the rebuilding of Windsor Castle after the defeat of Napoleon in 1815. The royal seat was intimately associated with English history from the signing of the Magna Carta at nearby Runnymede to the Glorious Revolution when William of Orange had installed himself there. So too, when the old Palace of Westminster (the Houses of Parliament) burned down in 1834, the brief for its rebuilding was, despite objections from neo-classicists, 'either Gothic or Elizabethan'. This was the 'natural' choice—a national style that embodied continuity, sustainability, and heritage; authority, prosperity, and society; and constitutional monarchy, liberty, and Anglicanism.

Churches

Charles Barry designed the New Palace of Westminster with Augustus Welby Pugin: Barry designing the layout, while Pugin was responsible for the intricate interiors including the awe-inspiring House of Lords. The plan of the building symbolizes the constitutional nature of the monarchy: the monarch rules only by virtue of parliament, but parliament itself is reliant on the sovereign for its legitimacy. Hence the royal throne in the House of Lords and the Speaker's Chair in the House of Commons lie on either side of the Central Lobby, constitutionally balanced and interdependent. The New Palace of Westminster was also made possible by industrial manufacturing methods for its decoration and the new engineering possibilities of iron frames for its structure. It was a very contemporary form of Gothic, the symbol of a modern Britain.

If contemporary liberal values were exemplified in the fabric of Westminster, they had also shifted the balance of religious power in the country. Nonconformists and Roman Catholics were permitted the same privileges as Anglicans in the emancipation legislation of 1828 and 1829, and popular radicalism and scientific advances perceived the church as reactionary and even irrelevant. In keeping with the prevailing Gothic emphasis, the Church of England found stability in its own history. In *Tracts for the Times* (1835–41), the leaders of the Oxford Movement (John Henry Newman, Edward Pusey, and John Keble) repositioned the faith by looking back to the past. High Church Anglicanism was presented as continuous with mediaeval Catholicism, its spiritual role in the life of the nation conducted independently of parliamentary interference.

The Tractarian cause was given terrific momentum in 1836 when Pugin published *Contrasts: or, A Parallel between the Noble Edifices of the Middle Ages and Corresponding Buildings of the Present Day*. In this polemic, Pugin argues that architecture is the physical manifestation of moral values and social cohesion. He reflects scathingly not only on 'pagan' classicism but also on the iconoclasm of the Reformation, in which the true 'Christian Architecture' of England, and thereby its moral fabric, was literally ruined. To demonstrate his thesis, *Contrasts* was printed precisely as a series of contrasts: images of mediaeval splendour and organic community directly confronting the commercial designs and exploitative practices of the modern world (see Figure 9). The 'Modern Poor House', for example, is a utilitarian panopticon that imprisons and virtually starves inmates, the master is armed with a cat o' nine tails, and the dead are sold for dissection. The 'Antient Poor Hoyse', in contrast, is a gorgeous quadrangle in the precincts of a Decorated Gothic church, the almshouses have productive allotments, the clergy rule benevolently, food is plentiful, and the dead are afforded Christian dignity.

This lament for the lost world of the Middle Ages is echoed in William Cobbett's *Rural Rides* (1830) and Thomas Carlyle's *Past*

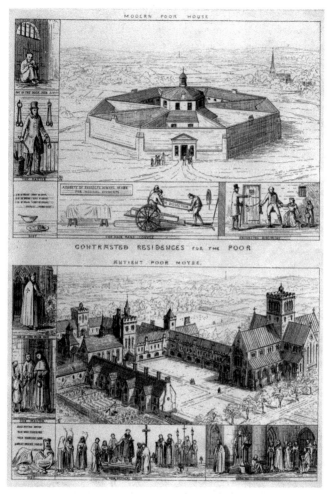

9. Pugin's Engraving from *Contrasts* (1841) comparing the grinding reality of life, death, and annihilation in the revived paganism of a 'Modern Poor House' with the community, spirituality, and faith of the truly Christian 'Antient Poor Hoyse'

and Present (1843). Both works repositioned the Gothic as communal and traditional, a pre-industrial rural idyll. 'Merrie England' was a powerful shared dream: by 1850 the majority of Britain's population lived in cities. But for Pugin it was less a dream than a vision, and he suggested that by constructing mediaeval buildings in mediaeval style, some of the old values could be revived. Hence in *True Principles of Pointed or Christian Architecture* (1841), Pugin argued that

> The two great rules for design are these: 1*st, that there should be no features about a building which are not necessary for convenience, construction, or propriety*; 2*nd, that all ornament should consist of enrichment of the essential construction of the building.*

The architectural intentions and therefore the integrity of a building should be clearly evident and 'the smallest detail should *have a meaning or serve a purpose*'. A pinnacle, for instance, both directed rain into the guttering and also gestured to Heaven as a symbol of the Resurrection.

Pugin found allies for his projects in the Cambridge Camden Society (1839), later the Ecclesiological Society (1846). By combining Tractarianism with the 'true principles' of Pugin's structural Gothic, the aim of the Ecclesiologists was to reinstate the mediaeval sanctity—what they termed the 'Christian Reality' or 'Sacramentality'—of every ecclesiastical artefact and construction. Hence the Gothic was made to teem with meaning. The first decade of the fourteenth century was identified as the signal Gothic moment (rather confusingly designated 'Early Late Middle Pointed'), and favoured examples were, not surprisingly, the country churches of pre-capitalist England. The influence of the Ecclesiologists was immense: thousands of rural parish churches were restored and constructed, and a burgeoning market for mediaeval arts and crafts, from stained-glass windows to inlaid tiles, was created. This craze for the trappings and purity of mediaeval Catholicism was for some too close to Rome, not least

because Pugin and Newman had both converted; as one pamphlet put it, *The 'Restoration of Churches' is the Restoration of Popery* (1844). But as gleefully reported in *The Ecclesiologist* at the time, the Gothic Revival soon went international. It was carried across the British Empire from Bombay to New Brunswick to Tasmania, and Pugin provided designs for several churches in Australia. Pre-fabricated chapels were manufactured in Britain for missionary work abroad, while elsewhere local building materials such as wood were employed in construction.

In the rest of the world, the new Gothic architectural style ran deepest in Belgium where it was led by Jean-Baptiste Bethune, a Puginian architect who also worked in stained-glass, metal and woodwork, and even vestments. In Germany, the Gothic connected national with religious history and was politically allied to German unification (1871), although the most renowned examples of Revival architecture were built by Ludwig II of Bavaria—most notably the Wagnerian fantasy of Neuschwanstein (1868), later the model for Walt Disney's castles in *Sleeping Beauty* and *Snow White* and also the company logo. In France, meanwhile, a stylistic theory of Gothic was developed based on principles of absolute functionality in form and materials. Buildings were perceived as evidence of pioneering systems of construction that effectively lay outside history in a realm of absolute truth and architectural integrity. Eugène Viollet le Duc, who masterminded the French Gothic revival, thereby shifted attention from tradition to function. Consequently, the original flying buttresses of Notre Dame (probably the first ever made) were replaced as they were understood to be merely rudimentary examples of innovative building practice.

The State

Industrial building methods and materials such as ironwork decorations made church restorations and new ecclesiastical commissions cheap and economical, but this market-driven

Gothicism also embedded the style in capitalist thinking and monetary value. In *The Stones of Venice* (1851–3), the art critic John Ruskin drew attention to the artists, craftsmen, and labourers who actually made the buildings. In 'The Nature of Gothic', the central chapter of the work, he scrutinizes the morality of buildings, disclosing the 'mental tendencies' of its workforce. He contrasts this to a Victorian drawing room, in which Gothic household paraphernalia are not the expressions of artistic creativity but the products of mass capitalism. This leads him to celebrate imperfection as a response to the 'relentless requirement of perfection' that not only drove classicism but which is in modern industrial society a form of enslavement. Instead,

> Go forth again to gaze upon the old cathedral front, where you have smiled so often at the fantastic ignorance of the old sculptors: examine once more those ugly goblins, and formless monsters, and stern statues, anatomiless and rigid; but do not mock at them, for they are signs of the life and liberty of every workman who struck the stone; a freedom of thought, and rank in scale of being, such as no laws, no charters, no charities can secure; but which must be the first aim of all Europe at this day to regain for her children.

Imperfection is what animates the Gothic building: it gives the architecture life.

For Ruskin, every Gothic building is different and unique, and Gothicism exists in the inventive mingling of features rather than in the pointed arch or vaulted roof or flying buttress. The buildings are therefore expressive of the artisans and builders who made them:

> The characteristic or moral elements of Gothic are the following, placed in the order of their importance

1. Savageness.
2. Changefulness.
3. Naturalism.

4. Grotesqueness.

5. Rigidity.

6. Redundance.

These characters are here expressed as belonging to the building; as belonging to the builder, they would be expressed thus:—

1. Savageness or Rudeness.	2. Love of Change.	3. Love of Nature.
4. Disturbed Imagination.	5. Obstinacy.	6. Generosity.

Ruskin therefore rethinks Gothic freedom as a way of challenging the grinding conditions of industrial capitalism. Indeed, the alienation of labour characteristic of capitalism directly connects Ruskin's theorization to the very language of Gothic literature. Consumer society could only be described in ghostly terms—'The world looks often quite spectral to me', wrote Thomas Carlyle in 1835—or as William Morris put it in his journal *Commonweal* (1890), by reasserting the ancient Gothic spirit of rebellion: 'we shall be our own Goths, and at whatever cost break up again the new tyrannous Empire of Capitalism'.

Ruskin effectively sought to eradicate the very conditions of mass-market capitalism and industrial production that had made the Victorian Gothic Revival possible. He proposed a symbolic form of fabrication, and championed 'structural polychromy': the use of different coloured stones to create visual effects. Polychromatic masonry was therefore part of the construction of the building rather than simply a surface effect, but it also served a symbolic purpose by embedding identifiable materials from other regions and countries in the walls. Ruskinian architecture was not an abstract play of structural innovation or an elaborate meditation on mediaeval faith, but a pragmatic and meaningful statement of international unity.

Structural polychromy caught the imagination: it was endorsed by *The Ecclesiologist* and developed by William Butterfield—ironically by using mass-produced bricks. Despite

the individualism of Ruskin's theory, in practice it appeared to celebrate technological uniformity—most forthrightly perhaps in Butterfield's Keble College, Oxford (1873–6) and George Gilbert Scott's Midland Grand Hotel, St Pancras Station (1868–77). Moreover, following Ruskin's reconceptualization and given the possibilities of modern engineering materials, primarily iron, strict mediaevalism was abandoned for an unrestrained and exotic 'Free Gothic' influenced by continental models. The effect could be vertiginous or border on the claustrophobic, such as in the overwrought interiors of Cardiff Castle designed by William Burges from 1869. The Gothic had become decadent.

The Gothic Revival was fatally undermined by Ruskin's attacks on mass production, new engineering technologies such as steel frames, and Viollet le Duc's rationalism. But in England at least, the architectural school had achieved its aim. The majority of nineteenth-century ecclesiastical, civic, educational, and cultural buildings were built on Gothic principles. It was the sacred and national style, but in an increasingly secular society it inevitably began to look dated and conservative. Neither could Gothic be adequately domesticated to vernacular house building: it simply became another constituent of 'Old English', part of the pantheon of styles from 'Jacobethan' to Georgian. At the same time attitudes towards architectural conservation shifted away from authentic recreation: it was felt that restoration work should not aim at counterfeiting the work of bygone eras but be clearly visible. And finally, it was increasingly evident that the Victorian Gothic Revival was only made economically and physically possible by the profits and workforce of industrial capitalism: it was not a way of reforming social relations. Thus the architectural continuity that had driven the Revival was not only challenged, but rapidly dismantled. It has never recovered.

Chapter 11
New England Goths

If the repressed history behind Victorian Gothic lay in the hidden cost of progress—Protestantism, constitutional reform, industrialization, and imperialism—the United States was a different place with a different history. While it could be argued

10. Batman meets his match in Catwoman (*Batman Returns*, 1992). Later in the film Bruce Wayne (Batman) meets Selina Kyle (Catwoman) at the Maxquerade Ball—each oblivious of the other's secret identity; soundtracking their flirtation is 'Face to Face', a track recorded by English Goth band Siouxsie and the Banshees

that American Gothic today (such as the *Batman* franchise; see Figure 10) is primarily a response to the political indifference, international lawlessness, and hyper-exposed anxiety of the sole global superpower, such concerns do not much stir the country's heartlands. Instead, the unspeakable history that American Gothic addresses in literature is primarily race and slavery, whereas in film it is primarily sexual violence against women. And as Elizabeth Barrett Browning pointed out as early as 1848 in her poem 'The Runaway Slave at Pilgrim's Point', the two frequently overlap.

New World, new terror

'American Gothic' is a problematic term. The emergence of Gothic writing in the United States took place not as in England as part of a diverse and ongoing history, but all at once, simultaneous with other literary innovations, and of course in a wholly different context. North America lacked the myths of antiquity, the mediaeval ecclesiastical and castellar architecture, and the ruins in which Britain and the rest of Europe located its Gothicisim. The history of the white settlers and their black slaves was comparatively short, the history of the native peoples obscure and unrecorded. There has consequently been a reluctance to identify an American Gothic literary tradition at all, and Gothic is often treated as a subgenre of melodrama or romance to distance American writing from the concerns and traditions of European, particularly English, literature.

But American Gothic was not simply a generic way of giving voice to the dispossessed. It had deep historical roots: a Puritan theology derived from the Reformation, a political identity based on seventeenth-century theories of constitutional freedoms, and a migrant culture of European folklore and literature that was strongly based in the contemporary British and German booktrade. Indeed, there were concerted European efforts to maintain American readerships and markets, and in 1818 Sydney Smith wrote in the *Edinburgh Review*, 'why should the

Americans write books, when a six weeks' passage brings them, in their own tongue, our sense, science and genius, in bales and hogsheads?' Similarly, Gothic Revival architecture spread through such publications as Loudon's *Encyclopaedia*, and Ruskinian Gothic eventually developed as the American style for cultural architecture—enthusiastically adapting polychromatic brickwork and muscular lines while simultaneously asserting European connections. In particular, American church architecture was adapted to specific regions by building in, for example, local timber, while retaining the typical pointed arch windows and spires. As in Europe, this cultural and ecclesiastical style was contrasted with the classicist models favoured for civic architecture.

Consequently, Gothic Revival designs became associated with republicanism and the Gothic myth was distinctively reworked to engage the destiny of the United States. *Vox Populi, Vox Dei*, for example, a popular tract on the Gothic polity between King and Commons which ran through nine English editions in 1709–10, was republished in 1771 as *The Judgement of Whole Kingdoms* and influenced the thinking of the American revolutionary Henry Laurens, President of the Continental Congress from 1777–8. Similarly, Thomas Jefferson not only compared American settlers with the Anglo-Saxons in *The Rights of British America* (1775), but even intended to include the Jute chieftans Hengist and Horsa on the Great Seal of the United States. Thus, in *The Goths in New England* (1843), George Perkins Marsh could argue that, 'It was the spirit of the Goth that guided the Mayflower across the trackless ocean; the blood of the Goth that flowed at Bunker Hill.' This was the maternal heritage of home:

> England is Gothic by birth, Roman by adoption. Whatever she
> has of true moral grandeur, of higher intellectual power, she owes
> to the Gothic mother; while her grasping ambition, her material
> energies, her spirit of exclusive selfishness, are due to the Roman
> nurse.

If America owed an undeniable cultural debt to the home countries, and early American writing was consequently a postcolonial literature written by conventions that governed another culture, society, and geography, it was also clear that the New World was not a satellite of Europe and faced its own challenges. It was a frontier society on the edge of the most extreme and threatening landscapes then imaginable, defined by its border with the wilderness as well as by its relationship with indigenous native tribes. America's difference presented an opportunity for a new sort of literature, a new sort of Gothic. As Charles Brockden Brown, arguably the first professional author in the US, put it,

> One merit the writer may at least claim; that of calling forth the passions and engaging the sympathy. Puerile superstition and exploded manners; Gothic castles and chimeras, are the materials usually employed for this end. The incidents of Indian hostility, and the perils of the western wilderness, are far more suitable; and, for a native of America to overlook these, would admit of no apology.

The Gothic could therefore give voice to the rebellion from Britain and the founding of the nation: utopianism and its discontents. One consequence of this was to internalize the European historical condition, making American Gothic a more psychological style. But the most extreme atrocities were not those that dealt with the break from Europe and environmental fears, but the lingering consequences of European imperialism and international capitalism: slavery and the African-American experience. Domination and enslavement, torture and murder, rape and sexual violence—it is no coincidence that these form the themes of American Gothic writing and later horror movies.

White Gothic

In the famous words of Leslie Fiedler writing in 1966, American fiction is 'bewilderingly and embarrassingly, a gothic fiction,

non-realistic and negative, sadist and melodramatic—a literature of darkness and the grotesque in a land of light and affirmation'. This is apparent from the earliest novels. Accounts of the American literary tradition are predisposed to identifying origins rather than considering a continuous history of culture, and Brockden Brown's *Wieland, or The Transformation: An American Tale* (1798) is treated as a founding text. This ultra-Gothic fantasy includes religious extremism, political radicalism, secret cults, spontaneous human combustion, ventriloquism, prophetic dreams, seduction, sacrifice, murder, and suicide—all described in a series of letters. The author explained that

> The incidents are extraordinary and rare. Some of them approach, perhaps, as nearly to the nature of miracles as can be done by that which is not truly miraculous.

He thought highly enough of the book to send a copy to Thomas Jefferson.

Edgar Allan Poe is, however, perhaps the most renowned of the early American Gothic writers. His debt to English and German Romanticism (via *Blackwood's*) was explicit, and many of his stories used recognizably European settings in symbolic ways: the deluded architecture of 'William Wilson', the subterranean world of 'The Cask of Amontillado', and most notably the precarious fabric of 'The Fall of the House of Usher'. But Poe claimed in *Tales of the Grotesque and Arabesque* (1839) that 'my terror is not of Germany, but of the soul'. He aimed at an internalized and often domesticated 'unity of effect'—a forerunner of Expressionism.

Poe's plots blend excruciatingly protracted suspense with implacable authoritarian power. They revolve around incarceration, entrapment, and imprisonment, including live burial and victims bricked up underground or behind walls. Narrators are often delusional, sometimes completely insane. Such accounts of suffocating claustrophobia are in stark contrast

to the environmental thinking of the time that promoted the freedom of the wilderness, the frontier spirit, transcendentalist faith in nature, and what was to become the 'American Dream'. Poe's stories usually take place in built environments. In 'The Man of the Crowd' (1840), the narrator trails a mysterious figure through city streets, reading the anonymous individual like a sign, following him like a plot, scrutinizing him like a daguerreotype. He is 'the type and genius of deep crime', who obliviously acts upon the narrator as a character of 'vast mental power, of caution, of penuriousness, of avarice, of coolness, of malice, of bloodthirstiness, of triumph, of merriment, of excessive terror, of intense, of extreme—despair'. Much as dream mystifies De Quincey's London, Poe's urban space becomes a limitless canvas for the imagination, sublimely terrifying.

But it is Poe's intensely troubling engagement with race that makes his writing central to American Gothic—it has also been sufficient reason for some critics dismiss his work as the thinly veiled prejudices of a racist pro-slaver. Poe was certainly writing at a time at which the differences between races were being seen as indicative of deeper differences, contrary to the account of primal origins in the Bible and earlier theories of racial migration in which the Goths had played such an energetic part. Polygenism in fact emerged from attention to race during the Enlightenment among commentators such as Voltaire and quickly became an ideological justification for slavery. By 1839, Samuel George Morton, Professor of Anatomy at the University of Pennsylvania, was publishing the results of his 'craniometry' in *Crania Americana*. This proposed that blacks were intellectually inferior to whites.

Poe's supposed racism reflected political, scientific, and aesthetic thinking of the time, but in ways that fearfully contested these attitudes. 'Hop-Frog; or, The Eight Chained Orang-utans' (1849), for instance, depicts slave rebellion and lynching. Hop-Frog, a subjugated dwarf acting as court jester, persuades the king and his privy councillors to dress as orang-utans chained together so as to

frighten the guests at a masquerade. Hop-Frog then hoists them to the ceiling and sets fire to their tarred costumes. They are burnt alive in revenge for the king earlier striking a dancer, also enslaved to the court.

The fear of slave retribution also saturates 'The Black Cat' (1843), the tale of a vengeful revenant. In this story, the narrator half-blinds and then hangs a black cat. He is befriended by another cat that haunts him with memories of the cruel deed, until in determining to kill this cat he inadvertently strikes his wife dead. Apparently unconcerned, he bricks her up in a wall, but unwittingly also seals in the cat with her corpse. The cat feeds on her decaying face and eventually calls for the authorities: 'a wailing shriek, half of horror and half of triumph, such as might have arisen only out of hell, conjointly from the throats of the damned in their agony'. The story is far more than an example of the 'uncanny'—what Freud would later (1919) define as what ought to have been 'secret and hidden but has come to light'. Rather, it again confronts the caprice of the lynch-mob and the sentimentalization of slaves as pets, as well as inter-racial sexual relations.

'The Black Cat' is also a trenchant account of the subjection of women, and the repressed history of gender relations could form a corollary to readings of American Gothic as inflected by race. Poe's 'Ligeia' (1838) and particularly 'Berenice' (1835) objectify and dismember women—not only symbolically in the fetishization of Berenice's gleaming teeth, but in the very actions of the protagonist. When Berenice apparently dies, her obsessed fiancé Egaeus exhumes her body in order to extract the thirty-two objects of his desire, an act of such hideous insanity that he entirely suppresses it. Berenice herself, however, had merely been in a cataleptic state—a victim of live-burial whose extraction from the grave by her lover is simply a bleakly ironic overture to his extraction of all of her teeth. This tradition of extreme psychological intensity and self-censorship culminated fifty years later in Charlotte Perkins

Stetson's 'The Yellow Wallpaper' (née Gilman, 1892), a
first-person account of imprisonment, infantilization, medicalization,
and madness in which a female patient is driven to extreme
psychological disturbance and possibly suicide by the delirious
wallpaper that covers her cell. The grotesque patterns are, if not
Gothic, at least architecturally archaic: 'the bloated curves and
flourishes—a kind of debased Romanesque with *delirium
tremens*—go waddling up and down in isolated columns of
fatuity'.

Black Gothic

Race is also prevalent in Herman Melville's *Moby-Dick* (1851).
The eponymous whale that preys on humans and their craft is an
indecipherable, barely describable monster. It is also white: 'It
was the whiteness of the whale that above all things appalled me.'
Its colourless colour becomes an inversion of white supremacy, a
negation of social order, as well as a grim reminder of the history
of Puritan asceticism. *Moby-Dick* is Colonial Gothic driven by
slavery, but it also has strong foundations in English Gothic. The
decks of the whaling ship The Pequod are 'worn and wrinkled,
like the pilgrim-worshipped flagstone in Canterbury Cathedral
where Becket bled', and Ishmael at one point invokes the
martyrdom of the Protestant Thomas Cranmer, one of the
highlights of Foxe's *Acts and Monuments*. In describing the
intoxicating reveries that can overtake the lookout in a crow's-
nest, he warns

> In this enchanted mood, thy spirit ebbs away to whence it came;
> becomes diffused through space and time; like Cranmer's sprinkled
> Pantheistic ashes, forming at last a part of every shore the whole
> world over.

Cranmer's execution at the stake has apparently been subsumed
into American transcendentalism, laced with the Gothic horror of
being poised over a picturesque abyss:

Over Descartian vortices you hover. And perhaps at mid-day, in the fairest weather, with one half-throttled shriek you drop through the transparent air into the summer sea, no more to rise for ever.

Melville reminds us that Gothic aesthetics, while being capable of diagnosing and even challenging racial hierarchies through an emphasis on liberty and hybridity, are also, by his persistent reminders of pedigree and exoticism, entangled in the roots of slavery.

The inheritor of Poe–Melville Gothic is H. P. Lovecraft, whose fantastical horror tales externalize psychological trauma as something monstrously inexplicable:

All my stories, unconnected as they may be, are based on the fundamental lore or legend that this world was inhabited at some time by another race who, in practising black magic, lost their foothold and were expelled, yet live on outside, ever ready to take possession of this earth again.

For his 'Cthulhu' cycle (written *c*.1925–35), Lovecraft concocted unimaginable creatures that lie just outside the dimensions of human experience, waiting to get in. His heady style mixes prehistory and the seventeenth-century New England past with fears inspired by recent advances in science and mathematics. Lovecraft was frankly obsessed to a xenophobic level with miscegenation and the pollution of the human by monstrous others, but by voicing these anxieties in modern contexts, he effectively Gothicized whole new areas. Polar exploration had been a Gothic theme in *Frankenstein* and Darwinian evolution underwrote *Dracula*, but Lovecraft updated these fields and added new areas of dread in cosmic research and mathematical theory. The remote reaches of outer space and the crooked logic of non-Euclidean geometry provided the troubling settings for his strange tales, voicing fears of multiplying infinitudes and the counter-intuitive theories that were challenging classical

mechanics. Moreover, he raised conventions of authenticity to new levels. Not content with the found manuscript convention or first-person narrative, Lovecraft created a self-supporting world: a central New England town (Arkham), a university (Miskatonic), and complex textual sources—most notably the work of the 'Mad Arab' Abdul Alhazred: the *Kitab al-Azif* or *Necronomicon* is a book of forbidden knowledge that has a detailed bibliographical history, existing in variant editions and translations that weave through the shadowy past. Far from being a pulp writer, Lovecraft's influence reaches from the short fictions of Jorge-Luis Borges to contemporary role-playing games.

If writers from Poe to Melville to Lovecraft reveal the degree to which American Gothic has been imbricated in race, it is fitting that African-American writers have themselves adapted the Gothic as a stylistic resource in describing their history and plight. The slave autobiography *Narrative of the Life of Frederick Douglass* (1845), for instance, describes Douglass's resistance as both Christian and Gothic: 'it was a glorious resurrection, from the tomb of slavery!', and a century later Richard Wright described 'the oppression of the Negro' as a 'dense and heavy…shadow athwart our national life' (*Native Son*, 1940). The African-American appropriation of Gothic therefore asserts how the style may be reinvented (for example, in zombie narratives), rather than allowing it to remain a politically problematic genre. The fullest realization of this is undoubtedly Toni Morrison's harrowing novel *Beloved* (1987), dedicated to the 'Sixty Million and more' slaves who died. In the novel, the ghost of the baby 'Beloved' is manifested, like the history of slavery, as a 'perfect dilemma'. According to Morrison:

> You can't absorb it; it's too terrible. So you just try your best to put it behind you.…Forgetting is unacceptable. Remembering is unacceptable.

Morrison de-sensationalizes the generic excesses of rape, torture, and murder, and in doing so restores humanity to the Gothic. Admittedly the associations of the Gothic not only with tribal origins but, far more importantly, with moral or physical horror make it a problematic vehicle for the declaration of black identity, as it risks associating blackness with the monstrous. In a later critical study, *Playing in the Dark* (1992), Morrison considers using a word like 'darkness' instead of Gothic so as to sidestep historical associations rooted in white society, but to do so would evacuate the genre of historical meaning. Instead, Morrison argues that although slavery, racial discrimination, and dehumanization are encoded in the Gothic, particularly American Gothic, African-American identity still needs to assert itself as being black. If that creates problems for the Gothic by politicizing its history, then so much the better. And history certainly has been politicized: in his speech on race during the 2008 presidential campaign, Barack Obama quoted from William Faulkner's experimental Gothic novel *Requiem for a Nun* (1951):

The past isn't dead. It isn't even past.

Chapter 12
The ghost in the machine

Despite its profound historical basis, the Gothic has always been a state-of-the-art movement. Just as modern Gothic building possibilities superseded the structural mediaevalism of Pugin, so the latest scientific developments in anatomy, the circulation of the blood, and infection, as well as galvanism, drug use, and psychology were the raw materials of Gothic writers from John Polidori and Mary Shelley to Wilkie Collins and Richard Marsh. Consequently the attraction the moving image had for the Gothic imagination was not just a lucky consequence of its visual and narrative appeal, it was part of the very activity of Gothic as a highly technologically aware style.

Scenes on the cinema screen could be presented in radical new perspectives, or could be switched instantaneously, making edits powerfully dramatic and splicing a narrative device. Scenes that would have been impossible to stage—cutting between angles, locations, even different states of mind such as dream sequences—became standard, creating a significant break with the Aristotleian unities and offering an implicit nod towards earlier Gothic aesthetic freedoms. Furthermore, rapidly innovated special effects and camera techniques made the moving image a stunning new tool in representing not only fantastic visions, but also in making the familiar mysterious.

Likewise, the sound revolution presented startling new possibilities for alarming aural effects—creaking doors, echoing footsteps, thunderstorms.

Although there was never a defined 'Gothic Art' movement, the cinema had a rich visual heritage to draw upon before it even began: Henry Fuseli's *Nightmare* and Gustave Doré's dreamlike visions of Dante's *Inferno* and Milton's *Paradise Lost* were popular and widely disseminated as engravings. Likewise, all the successful Gothic novels were adapted for the theatre and many novelists also wrote for the stage, which was a potentially more profitable medium than literature. The Gothic was consequently instrumental in the developing the English 'melodrama' (the term was first used in 1802), and audiences thrilled to early special effects in waxwork figures and the innovative ways in which scenes were lit. Gothic phantasmagorias, popular from the 1790s, were magic lantern shows that combined moving slides and lanterns, spectral lighting and smoke effects, and soundtracks performed on barrel organs or to the arcane tones of the hurdy-gurdy. While the uncanny freeze-frames of Eadweard Muybridge focused on the most mundane of events (such as a galloping horse), other photographers captured ghosts on film, and from the 1850s stereoscopic pictures and photographs of eerie apparitions fed a culture transfixed by spiritualism. By the end of the century the first camera trick in cinema history (locking off the camera while an actor was replaced by a dummy) was performed in filming a central episode in English Protestant history: the beheading of Mary, Queen of Scots.

Gothic cinema derives directly from these sensational visual technologies. Black-and-white *chiaroscuro* was ideally suited to Gothic style from the outset—indeed films are watched in the dark—but it was also the demand for new cinematic experiences such as camera trickery, special effects, fantastical scenery, and monstrous figures that merged in a new visual

style. In the cinema, the Gothic was deliberately updated and came to represent a distinct aesthetic. And just as the Gothic Revival reflected imperial attitudes and anxieties in Victorian Britain, Gothic cinema was likewise shaped by social and political forces. Great War trauma in Weimar Germany, mid-century isolationism in America, and British attempts at cultural renewal after the Second World War: all motivated the medium.

Weimar

The most significant example of early Gothic cinema is Robert Wiene's *The Cabinet of Dr Caligari* (1920). *Caligari* was based on two earlier films: *The Student of Prague* (1913), which described a man selling his reflection, and *The Golem* (1915), a traditional fable about the creation of a monster—it therefore had its roots in both supernatural folklore and cinema history. But *Caligari* also dramatizes the horrors of the Western Front during the Great War (1914–18)—that of 'the authoritative power of an inhuman state gone mad', as one of the scriptwriters put it. In the film, Dr Caligari is a deranged scientist who exhibits the somnambulist Cesar as a carnival sideshow. Cesar, it transpires, is under the mad doctor's control, who directs him in his sleep to murder female victims: soldiers were, like Cesar, effectively the walking dead—under the power of insane forces that drove them to kill.

In order to represent this nightmarish world, the film developed an Expressionist *mise-en-scène*. Expressionism was a *Weltanschauung*—a way of looking at the world influenced by the paintings of Vincent Van Gogh and Edvard Munch that captured distorted mental states in 'brain photography'. Expressionist style therefore emphasized the necessity of every element in a composition—which in cinema meant the perfect coincidence of action, camera work, and scenery. The sets for *Caligari* were consequently wildly asymmetric—painted on canvas as dislocated,

angular, and heavily shadowed. The actors performed in mannered and exaggerated gestures derived from an earlier theatrical age, and the score comprised fragments from Igor Stravinsky and other modernist works. The combined effect of all this was to create an absorbing, even hypnotic, experience that mirrored the themes of madness and loss of selfhood that saturated the film. In the US, *Caligari* was compared with Poe's earlier tales of claustrophobia and subjection. In Germany, however, the experimental artistry of Expressionism helped to give the new Weimar Republic a cultural identity that was forward-looking, modern, and progressive.

The German studio UFA that produced *Caligari* was also responsible for other central films of the Weimar era, including *Nosferatu, A Symphony of Terror* (F. W. Murnau, 1922). *Nosferatu* was a defining work of Gothic cinema and the first vampire film. It was heavily based on Stoker's novel, but made no acknowledgement of its debt: it was truly vampiric.

Although not explicitly Expressionist, *Nosferatu* was certainly visually distorted and heavily stylized, deploying extreme effects of *chiaroscuro* and defamiliarization. Count Orlok, the vampire, was a grotesque gargoyle and a plague-bringer who seems to have stepped straight out of the Dance of Death tradition (as well as being arguably an anti-semitic monster). Orlok is utterly alien, and certainly no seducer—indeed, sexuality in *Nosferatu* is really a metaphor for oppression, and like *Caligari* the film is fascinated by the exertion of absolute control over others. *Nosferatu* is an experience of infectious voyeurism and predation: the world is exposed as a ravenous chain of consumption, a fearful vision realized in the film in overlapping networks of communication, contamination, and bestial genealogy. In Van Helsing's experiments, the lust of carnivorousness is traced from cannibalistic polyps to the Venus flytrap to the hyena—and ultimately to the cinema audience itself.

In its fascination with the transference and exchange of identity, *Nosferatu* can also be seen as a cultural expression of post-war trauma—between the end of the war and the signing of the Treaty of Versailles, 700,000 Germans had died of starvation. For its naturalistic sets, *Nosferatu* drew on the Romantic artist Caspar David Friedrich, whose hallucinatory landscapes were rediscovered at the beginning of the century. These picturesque settings are supernaturalized in the film not only by the presence of the vampire, but also in time-lapse photography and cross-cutting between different locations to disorientate the audience. The land becomes strange. And although Orlok's castle (Orava) is predominantly Romanesque, it has significant Gothic features. At one point the film frames Count Orlok within a pointed arch as if it were his coffin, recasting the symbolism of Gothic architecture for the new medium of the moving image (see Figure 11).

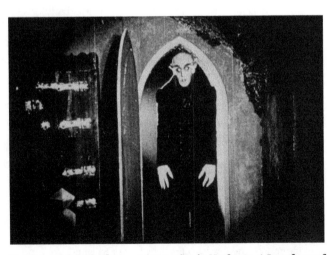

11. Count Orlok, the first screen vampire, in *Nosferatu, A Symphony of Terror* (1922). Chillingly freakish, undead and inhuman, the vampire lurks in doorways, at the threshold of dreams, between being and nothingness

Hollywood

Despite the international successes of early German cinema, Expressionism was condemned by the Nazis as degenerate. Many filmmakers migrated to the US and settled in Hollywood where they became involved in the next generation of both Gothic film and what was later described as *film noir*. *Dracula* and *Frankenstein* again proved particularly compelling sources. In the wake of *Nosferatu*, John Balderston and Hamilton Deane had adapted *Dracula* for the stage in 1927 and this version was filmed by Tod Browning in 1931 with Bela Lugosi playing the vampire. Lugosi reinvented the role, and in doing so became a screen icon. Unlike the bald, skeletal, sharp-toothed, and long-nailed Orlok, Lugosi's Dracula was slick and groomed, resplendent in full evening wear. He looked more like a foreign diplomat—or a theatrical impresario. Lugosi refused to engage in any supernatural activity; he did not even wear fangs. But his thick Hungarian accent, opaque manners, and simmering violence emphasized his difference, his foreignness. Lugosi made vampirism a facet of the archaic culture of Eastern Europe: in other words, he played Dracula as a Goth.

Frankenstein was also reinvented for American audiences. It was Peggy Webling's 1927 stage version that first named the monster as 'Frankenstein' and his creator as 'Henry', casting both parts to the same actor, but it was James Whale's film of 1931 that did for the Monster what Bela Lugosi had done for Dracula. Whale's Monster (billed as '?') was played with halting humanity by Boris Karloff. This pitiable portrayal proved a monster success, and inspired other sympathetic creature movies, including *King Kong* (Merian Cooper, 1933). Whale's sequel, *The Bride of Frankenstein* (1935), introduced the bride-to-be of the Monster: the equally iconic Elsa Lanchester, who also doubled in the role of Mary Shelley in the film's prologue.

Lugosi's Dracula cut a deliberately melodramatic figure among the naturalistic actors with whom he shared the screen; likewise,

Karloff's Monster, communicating through gesture rather than words, seems to be a throwback to the silent era. Neither had any sexual allure either—they were simply anachronistic threats. But the popularity of these films in the US reveals how the typology of the Gothic could shift in new national, cultural, and political contexts: from imperial Victorian consumerism to the new moralistic austerity of America—the America of the Great Depression, prohibition, and isolationist foreign policy. *Frankenstein* and its sequel were also tangential comments on miscegenation, while *Dracula* once again was manifested as the invisible other, the reverse colonialism this time being the threat from Eastern Europe—in particular communist Russia. Other films went further: *Invasion of the Body Snatchers* (Don Siegal, 1956) described a mass-*doppelgänger* invasion that insistently confronted American fears of communism and the consequent depersonalization of identity. Moreover, the cinema was not only the medium for projecting Gothic characters and plots, it was their very being. In the case of *Frankenstein*, the creature is animated by electricity and light, the basis of cinema. Likewise in *Dracula* the screen becomes the medium of reanimation, replaying events in an eternal recurrence that vampirically preys on the viewer, allowing the Count to cheat death time and time again.

Most notorious in mid-century American Gothic cinema, however, is Tod Browning's *Freaks* (1932). Contrasting with both the heavy monstrosity of Karloff and the sinister familiarity of Lugosi, *Freaks* dissolved definitions of the normal and abnormal. It is a film that radically confronts cinematic authenticity by abandoning special effects in favour of 'sports of nature'. For the majority of his cast, Browning employed circus sideshow performers: a bearded lady, an intersexual hermaphrodite, the 'Human Skeleton', midgets, conjoined twins, and 'Pinheads' (microcephalics). It remains one of the most challenging films ever made—a distinctly uncomfortable exercise in voyeurism and objectification—and poses unanswerable questions about identity, normality, and artistic morality.

Freaks focuses on the domesticity of the sideshow performers in contrast to the vicious scheming of two able-bodied acrobats, Cleopatra the trapeze artist and Hercules the strong man, who ensnare and attempt to poison the midget Hans (revealingly, the very names of the central characters suggest an opposition between classical history and Germanic folklore). Learning of these plans, the 'freaks' pursue the two villains during a torrential downpour. Cleo is captured and mutilated, and she ends up as a sideshow herself—the quadriplegic 'Duck Woman' able only to quack—whereas Hercules is never heard of again. (In the original uncut version Hercules was also mutilated and turned into a sideshow as a castrato singer.) So in addition to disclosing the ordinariness of 'freak' society—the 'Living Torso' lighting and smoking a cigarette or the 'Armless Woman' drinking from a glass held by her toes—the 'freaks' are shown to comprise a murderous, gang-like subculture. *Freaks* therefore radically departs from the cinematic depiction of monstrosity as a series of special effects by relentlessly insisting on the documentary reality of its portrayal while unsettling the audience with its disturbing plot twists, by turns banal and brutal. Nature becomes unnatural and the whole notion of authenticity is exposed as a set of conventions.

Hammer

According to David Pirie writing in 1973, the characteristic development of Gothic cinema in Britain gave the world the horror movie:

> It certainly seems to be arguable on commercial, historical and artistic grounds that the horror genre, as it has been developed in this country by Hammer and its rivals, remains the only staple cinematic myth which Britain can properly claim as its own, and which relates to it in the same way as the western does to America.

Pirie argued that this was a consequence of the Gothic literary inheritance: these 'films...are in no way imitative of American or

European models but derive in general from literary sources'—
Frankenstein, *Dracula*, and in particular *Dr Jekyll and Mr Hyde*.

This literary basis, already evident in American Gothic cinema,
was especially prevalent after the Second World War, typified in
Britain by the Hammer House of Horror, and in America by the
prolific output of Roger Corman. Filmmakers on both sides of the
Atlantic gloried in post-war generational rebellion, sexual
liberation, looser attitudes to censorship, and the garish
possibilities of technicolour. Terence Fisher's *The Curse of
Frankenstein* (1957) introduced a camp yet menacing Peter
Cushing as Victor Frankenstein—a maverick, murderous scientist.
Corman meanwhile focused in the early sixties on reworking Poe,
casting Vincent Price in his leads. *The Masque of the Red Death*
(1964), for instance, is a bizarre hybrid of Poe's tale and
Shakespeare's play *The Tempest* that also draws on Lewis's *The
Monk*, Radcliffe's *The Italian*, and Maturin's *Melmoth the
Wanderer*. It is a macabre reinvention of the Dance of Death and
invokes the shameless amoralism of ballads, but the film also has a
distinctively pungent visual character in its extreme colour
schemes, intense claustrophobia, and dream passages.

Hammer Horror developed its own aesthetic of sex and violence,
most notably in reworkings of *Frankenstein* and *Dracula*. *The
Curse of Frankenstein* had already been attacked on its release for
sadism, and Hammer's *Dracula* films subsequently exploited the
seductive charm of Christopher Lee (*Dracula*, 1958; released as
Horror of Dracula in the US). Lee effectively returned to the fatal
attractions of Polidori's 'vampyre' Lord Ruthven. His first *Dracula*
role presents the Count as dapper, modish, and charming, keeping
a shiny neo-Gothic house: the performance was a statement of
Englishness referring back to Edwardian elegance, but also
acknowledged the contemporary style of post-austerity Britain.
This portrayal influenced other contemporary villains such as
Dr No and Ernst Stavro Blofeld, who both favoured sleek Nehru
jackets in their roles in James Bond movies.

These films assumed a sophisticated and ironic audience familiar with their sources, fascinated by the archaic. They also popularized the overt use of Christian images such as the sign of the cross as direct weapons against the vampire brood, and sensationalized the effect of sunlight, which spectacularly reduces the creatures to ashes (unlike Stoker's *Dracula*, it is the sun's rays and not dawn that affects the vampires). This itself was a knowing comment on the dark, inner space of the cinema and the photophobia of urban living, as well as a way of exploiting the erotic charge of the dark and feeding the passions of teenage audiences on Saturday-night dates. Huge liberties were taken with texts in sexualizing the genre, most notably in the titillating fantasy *Dr Jekyll and Sister Hyde* (1971, featuring Martine Beswick).

But Gothic cinema is about far more than polysexual libertinism and voluptuous perversion. The *mise-en-scènes* of towering castles and maze-like interiors, deep forests and unnerving ruins, impenetrable fogs and lashing rain clearly derive from the established Gothic imagery of writers, artists, and architects. This is not a superficial effect of staging: such scenic furniture reflects the spectrum of psychological states among characters and audiences, from anxious curiosity to sheer terror. It is as if all the pious mystery of Pugin, all the architectural vivacity of Butterfield, and all the castellar confidence of mediaevalism has become unutterably sinister. Ruskin wanted buildings and decorative style to mean something: in Gothic film they certainly do—in fact, like the scene of a crime they are overflowing with meaning—but it is not a significance that leads to social craftsmanship and communal living. Rather, this architecture has a rancid sublimity. History is monumental, grounded in castles, graveyards, and churches. Gothic styling is either the vehicle by which the cinema penetrates the remote and barbarous past, or a ruinous reminder of the destructive passage of time and the breakdown of all things—ultimately including technology itself. Gothic cinema is a revenant, haunted by its own demise.

Chapter 13
First and last and always

Gothic cinema is one of the most recognizable, easily exported, and effectively appropriated art forms of the twentieth century. It has become a worldwide phenomenon, carrying with it in often degraded forms the ethos of the Gothic Revival and features of earlier Gothic myth, from a belief in progress predicated on Western democratic values to an anachronistic ideal of old England. Consequently, it has been woven into the broader capitalist ideology of the West by providing a vast and potent lexicon of imagery.

Nowhere has this been taken up with more enthusiasm than in the United States of America. Gothic cinema conquered America, and continues to inform the aesthetics of television, comics, and graphic novels today. This is in part due to the influence of Sigmund Freud. Freud helped to lay the groundwork for the mass-intellectualization of cinema by early alerting directors and audiences to the psychological possibilities of the medium—and film certainly proved a flexible way of dramatizing the spectrum of mental states in visualizing dreams and generally living out fantasies. In this context, the Gothic in particular appeared to provide access to the dreamworld mapped by the new science of psychoanalysis: it was the stuff of nightmare, the fantastic, trauma, repression, and perversion. It should, of course, be remembered that as a centuries-old tradition it was the Gothic

that actually structured these apparently newly discovered psychological realms, and that Freud in any case hated the domestic technology of the telephone and radio—not to mention the cinema. Nevertheless, he arrived with Carl Jung in New York in 1908 like Dracula himself, declaring 'We bring them the plague, and they don't even know it'.

Goth-on-Goth film

Classic Gothic cinema continued to thrive after the American golden age and Hammer House of Horror. Both Francis Ford Coppola's *Bram Stoker's Dracula* (1992) and Kenneth Branagh's *Mary Shelley's Frankenstein* (1994) declare their literary sources while powerfully developing female protagonists and dwelling on gender relations. Moreover, Coppola meditates on the uncanniness of moving image technology by making the early history of the cinema part of his production. The sexual politics of vampires have also been romantically reinvented for teenage boys (*The Lost Boys*, Joel Schulmacher, 1987) and teenage girls (*The Twilight Saga*, 2008–12). Sexual mores are more seriously examined in *The Hunger* (Tony Scott, 1983), in which the vampires' thirst for blood is set against the emerging AIDS epidemic. *The Hunger* again features powerful female protagonists, Miriam the vampire and her nemesis Sarah.

Mediaevalist films too have good Gothic credentials in the older sense of the term. John Boorman's *Excalibur* (1981) mixes Romantic-realism with Arthurian sorcery to create a shadowy atmosphere suggestive of Keatsian poetry and Pre-Raphaelite painting, while *Elizabeth* (Shekhar Kapur, 1998) is filled with post-Counter-Reformation intrigue. Similarly, Derek Jarman's meditation *The Last of England* (1987), which analyses cultural heritage and the decay of national identity, also has a claim to be considered Gothic.

Alongside mediaevalist cinema, a genre of techno-Gothic movies has emerged, typified by Ridley Scott's *Alien* (1979)

and *Blade Runner* (1982), *Batman* (Tim Burton, 1989), and in films by David Lynch and David Cronenberg. Scott's *Alien* and *Blade Runner*, for example, both reinvent horror within high technology. Both films generate a *mise-en-scène* of extreme *chiaroscuro* and mistiness derived from *film noir* and in 'visual density': in *Alien*, for instance, the design of the creatures and their artefacts was given to artist H. R. Giger who created an organic alien look independent of the film's human stylings. These films are also both radical rewrites of Gothic literary classics: *Dracula* and *Frankenstein*, respectively—adding extreme monstrosity and alien matriarchal values to the fear of miscegenation, and technological sophistication to the question of what it is to be human. If *Alien* depicts alienation, *Blade Runner* deliberately describes dehumanization: those who appear to be human turn out to be automata—Replicants—possibly including the 'blade runner' Deckard himself. Dolls, models, and simulacra litter *Blade Runner*, a reminder that cinema is itself a projection of simulations on a screen—even if the end of the 'Director's Cut' version offers ambiguity rather than despair. Cyberpunk style (near-future and retro-fitted dystopian street fashion) was effectively defined by *Blade Runner*, and the film was a major influence on William Gibson's novel *Neuromancer* (1984) as well as the subsequent 'steampunk' movement.

The most gripping scenes in *Alien* were filmed on hand-held cameras, giving a raw, unedited immediacy to the drama. This was not simply to create a contrast to heighten the impact of the spectacular effects, but a way of authenticating the fictions of techno-Gothic. Other films have concentrated on this authenticity effect. *The Blair Witch Project* (Haxan, 1999) and *Paranormal Activity* (Oren Peli, 2007) are studies in authenticity that update the conventions of found manuscripts and literary textuality. In *Blair Witch* the authenticating device is recovered video tape; in *Paranormal Activity* it is 'found footage'. Both cultivate a deliberately amateur cinematic style.

Cinema horribilis

If American Gothic literature is a significant way of addressing racial identity, horror movies focus on sexual violence. The grand-daddy of this style is Alfred Hitchcock's iconic film *Psycho* (1960), and the Bates Motel is the *locus classicus* of the American haunted house: a brooding hilltop residence in a style Hitchcock dubbed 'California Gingerbread' (French Renaissance with a dash of Gothic Revival). *Psycho* initiated the style of later 'slasher' movies: sex and violence, mainly directed at attractive young women. In *Psycho* itself, the audience watches the victim Marion Crane through the eyes of Norman Bates, sharing the baleful gaze of the male serial-killer. Hitchcock certainly aimed to comment on the voyeurism of cinema audiences and his own shooting notes for the infamous shower scene read: 'The slashing. An impression of a knife slashing, as if tearing at the very screen, ripping the film.' But *Psycho* was also simultaneously parodic, lightly mocking its own horror: Bates's mother is, outrageously, a 'mummy'.

Hitchcock's psychological thrillers and Hammer films lie behind the cocktail of sex and blood that drove blockbuster horror films through the seventies and eighties. Slasher franchises such as *Friday the 13th* (Sean Cunningham, 1980) were typified by a wholly generic horror style derived from the visually sensational aspects of the Gothic: isolation, atrocious weather, inexplicable violence, the authentic vantage point of the serial killer, and gratuitous female nudity. This was in part an aggressive rejoinder to the feminist politics of the late 1960s—not least because cultural critics had succeeded in sexualizing the Gothic by repeatedly arguing that it was a vehicle, cinematic as well as literary, for patriarchal oppression and the objectification of the female body.

Among these sensationalist movies, *The Exorcist* (William Friedkin, 1973) and *The Omen* trilogy (1976–81) have some claim to a more sophisticated Gothicism by re-establishing Satanism

and witchcraft in a contemporary context. These films treat the works of the Devil as semiotic—in other words as sign systems that can be interpreted and deciphered. But they are also presented as real, and protagonists call on the Catholic Church to rectify the situation by exorcism—which does not of course occur in a film such as *Nosferatu*. Hardcore fans focus on such esoteric details as a way of immunizing against the horror of horror movies. They are connoisseurs, taking an objective pleasure in recognizing sources and analogues, quotations and allusions, inversions and innovations, and directorial style: historicizing, aestheticizing, technical, and pedantic—embedding films in genre and intertextuality to make them opportunities for discussion and subcultural formation. Appreciation is self-reflexive and aims to distance rather than engage. Moreover, watching horror films, especially controversial and censored examples, can be presented as an act of rebellion—albeit a passive, consumerist, reclusive, and unfocused act of rebellion.

Yet despite this scholarship of horror, the most striking examples of these films—such as *The Exorcist*, in which the twelve-year-old girl Regan is diabolically possessed, and the paranormal puberty thriller *Carrie* (Brian De Palma, 1976)—present female sexuality as savage and supernatural. Ironically, by focusing so unforgivingly on the suffering of women, these movies oblige audiences to identify with female victims—who then usually turn out to be the active, vengeful survivors. And as if underlining the feminization of the male gaze, these films also often include ambivalent sexualities, from the Oedipal cross-dressing of Norman Bates to the masochist fantasies of the *Hellraiser* franchise (Clive Barker, 1987).

Contemporary Gothic writers such as Stephen King, Anne Rice, and Poppy Z. Brite clearly have an acute awareness of horror movies as devices to explore the sexual power relationships inscribed in contemporary society. Angela Carter does so to stunning effect in *The Bloody Chamber* (1979): she was already an aficionado of the Gothic and its magical realist properties in 1974, writing,

characters and events are exaggerated beyond reality, to become symbols, ideas, passions...style will tend to become ornate and unnatural—and thus operate against the perennial human desire to believe the world as fact...[the Gothic] retains a singular moral function—that of provoking unease.

Similarly, the exemplary slasher fiction of Bret Easton Ellis's *American Psycho* (1991) is a postmodern reflection on the horrors of late-capitalist consumerism.

The cult of the horror movie has expanded with the mass availability of cheap DVDs and internet streaming. Like the television, it may be viewed alone in a domestic and private space. But TV tends towards the Gothic only in one-off literary adaptations such as Le Fanu's *Uncle Silas* (*The Dark Angel*, 1987) and Mervyn Peake's *Gormenghast* (2000), or in long-running series: *Twin Peaks*, *Buffy the Vampire Slayer*, and the 'New Vampirism' of *Twilight*, *et al.* 'Horror TV', on the other hand, is a non-sequitur. As Stephen King notes: 'Horror has not fared particularly well on TV, if you except something like the six o'clock news....It is very difficult to write a successful horror story in a world which is so full of real horror.'

The final chapter

In the late twentieth century a recognizable Gothic fashion style began to appear. Although it is often described as an offshoot of punk, rock bands such as Black Sabbath had already produced a body of work driven by detuned guitars and obsessed with introspection, insanity, and occultism. Alice Cooper had developed a gruesome stage act based on the Grand Guignol that included the torture and the unparalleled *coup de grace* of the execution of the lead singer. Both bands took inspiration from the cinema— notably Hammer House of Horror and *Barbarella* (Roger Vadim, 1968). At the same time, 'glam' rock was the predominant rock star look in both the androgyny of David Bowie and Marc Bolan as

well as the heavily made-up and confrontational transvestism of The Sweet and New York Dolls. Even Black Sabbath wore platform boots and satin capes at the time.

This chic was substantially developed in Britain by punk bands such as The Damned, Siouxsie and the Banshees, and UK Decay. The Damned released the first punk single in 1976, which featured a cover image of singer Dave Vanian ('Transyl-Vanian') dressed and made-up as Bela Lugosi, and Siouxsie Sioux was notable for sporting bondage gear. Abbo of the appropriately named band UK Decay coined the description 'Gothic' for this new musical genre. The word had already been used by David Bowie to describe his album *Diamond Dogs* (1974), and the Banshees and Joy Division had used it to describe the general tone of their music, but it was first used to describe a subculture in 1981.

The style that emerged was led by bands such as Bauhaus and the Sisters of Mercy. Bauhaus recorded the first Gothic single, 'Bela Lugosi's Dead' (see Figure 12), in 1979, and subsequent releases made overt use of German Expressionism and the visual style of Gothic cinema, especially film soundtracks: from eerie background music to the disturbing subsonic noise effects deployed in movies such as *The Exorcist*. Similarly, stage performances made melodramatic use of black and white *chiaroscuro*, or displayed an instinct for the Burkean sublime and the aesthetics of obscurity by smothering the band and audience in impenetrable dry ice, evoking the *film noir mise-en-scène* of *Blade Runner*.

It is easy to see all this as escapist fantasy provoked by nihilist disillusionment with consumerist society, appropriating the exploded religious iconography of a bygone age, and playing with love/death eroticism and sexual transgression. But the stark, etiolated, ultra-expressive, and almost predominantly funereal image of Goth also seemed to be a trenchant comment on the aging popular music scene in Britain. Malcolm McLaren

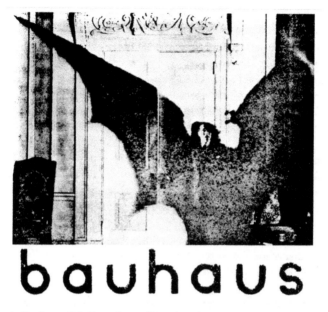

12. Bauhaus, *Bela Lugosi's Dead* (1979), a nine-minute single, was the overture to a new aesthetic: Goth. Pop music would never be the same again

(erstwhile manager of the Sex Pistols) had already described rock music as a 'tired old necrophiliac'. As ever, he was ahead of the game. The Goth scene was a comment on a music business haunted by past icons, cannibalizing its own heritage, and feeding on the latest youthful generation. The 'biz' were the blood-suckers, but it was the Goths who adopted a provocatively uncanny look to reflect the exhaustion of rock 'n' roll: its incessant repetitiveness, and the vampiric relationships that defined (and still define) the music industry. It is no coincidence that Bauhaus perform 'Bela Lugosi's Dead' at the beginning of *The Hunger*, a film in which David Bowie, the most enduring rock star of the age, is shown as horribly old, as the undead.

Goth style was therefore embedded in earlier uses of the Gothic: not only in generalized morbidity and despair and in the forms of ruin, but also in gauging the weight of history. This is also reflected in the scene's music. Gothic music is as diverse as any musical genre but can be characterized as a blend of clashing sounds and playing styles that are deliberately made remote, by guttural or operatic vocals, the deliberate but restrained use of modern technological effects, washes of synthesized sound that create a false sense of stability, metronomic drum machines that invoke inhuman backdrops or are weirdly innovative, and cinematic sampling. Soundscapes veer between the claustrophobic and the agoraphobic, lyrics describe imprisonment or vast open spaces, arrangements emphasize the distance between instruments, production effects allow songs to reverberate as if played in vast echoing cathedrals, across wastelands, or confined in inner space, and corroded environments are filled with voices, fragmentary sounds, and footsteps.

Although Goth has never enjoyed mainstream success, it displays an impressive longevity, and has developed into an international industry through artists such as Nick Cave and Andrew Eldritch, while also dividing into subgenres such as Darkwave. Gothic music today is best exemplified by the absorbing textures of Fields of the Nephilim (see Figure 13), a band that combines ancient Sumerian theology and early modern heresy into a peculiar neo-archaicism, while the literary inheritance of the Gothic survives in wild performances such as *Cacophony* (1987), Rudimentary Peni's scarifying homage to Lovecraft. A sister strand of mediaevalist music includes Dead Can Dance in Australia, Faun and Corvus Corax in Germany, and Miranda Sex Garden and the Daughters of Elvin in Britain.

Goth is unusual among subcultures in that it never developed the gang mentality of Teddy Boys, Mods, or Skinheads. It is romantically individualist, assuming the position of the outcast, the outsider, and the other. Although its early days were defined by exclusive

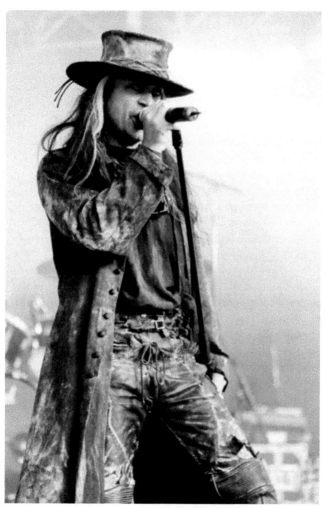

13. Fields of the Nephilim are a Gnostic riddle wrapped in a cultish enigma. Live performances are almost ritualistic, with members of the audience building themselves into 'towers' of human Gothic architecture. It is as if the entire ideology of the Gothic has been radically internalized

gigs and clubs—some of which survive to this day (The Wendy House and Black Sheep)—Goth now thrives in private spaces and has found a home in that infinite spectral labyrinth, the world-wide-web. This fascination with virtual technologies, reminiscent of *Dracula*'s emphasis on communication networks, sees some Goths adopting the futuristic look of cyborgs, while others dress in a 'steam-punk' style based on Victorian science fiction.

Goth is therefore a lifestyle choice for an alternative culture that now covers not only hairstyles and clothes, music and art, but also beliefs and philosophy (primarily the occult and the anarchic, although there are plenty of Christian Goths), sexuality, and body modification—making it the default style for BDSM clubs such as the Torture Garden. Goth has gone global. There is a distinctive fashion of 'Gothic Lolita' in Japan, mixing archaic and sexualized juvenilia with sado-masochistic and supernatural elements, while in the US Goth style has been adopted by 'shock rockers' such as Marilyn Manson, and NYC Goth, trading on 'Gotham City', is a magnet for American 'alt.culture'. With all this comes the risk that posing as pariah will attract scapegoating: it was perhaps inevitable that an irresponsible and panicking media should have accused the blameless 'Trenchcoat Mafia', a small group of American Goths, for the dreadful Columbine High School Massacre in 1999.

The culture of blame so stridently enforced in the aftermath of Columbine is symptomatic of how Western society treats difference, of how 'normality' is aggressively imposed. This is not simply reactive, it can be brutally proactive. In 2007, a twenty-year-old woman named Sophie Lancaster was beaten to death in a park in a Lancashire town simply because she was dressed as a Goth. This appalling hate crime has compelled the attention of poets such as Simon Armitage (*Black Roses*, 2011), and the Sophie Lancaster Foundation has been established in her memory. I cannot make sense of this terrible event by invoking the conflict between civilization and barbarism in late antiquity, or the

succeeding celebration of Gothic values as the foundation of modern society—but Sophie Lancaster deserves her place in the history of the Gothic. Her death is a chilling reminder that dissent, the lifeblood of a liberal and democratic society, can come at an awful cost. If the Gothic is as relevant today as it has been for the past millennium and a half, it is not because the Goths are still at the gate, it is—and always has been—the 'normals' who are the real threat. Which side are you on? I am on the side of Sophie Lancaster.

References

Preface

'In...nowhere'. Fred Botting, *The Gothic* (London: Routledge, 1995), 155.

Chapter 1: Origins of the Goths

All quotations from Jordanes from Charles C. Mierow, *The Gothic History of Jordanes* (Princeton, NJ: Princeton University Press, 1915).

Ammianus Marcellinus, *Roman History*, trans. John Rolfe, 3 vols, Loeb Classical Library (Cambridge, MA: Harvard University Press, 1940).

Claudian, trans. Maurice Platnauer, 2 vols, Loeb Classical Library (Cambridge MA: Harvard University Press, 1963), 142–4.

Gregory of Tours' remark that 'the Goths...upon': quoted by E. A. Thompson, *The Goths in Spain* (Oxford: Clarendon Press, 1969), 19.

Chapter 2: The ascent to heaven

Bramante: 'The...irrational': quoted by Chris Brooks, *The Gothic Revival* (London: Phaidon, 1999), 9.

Giorgio Vasari, *The Lives of the Artists*, trans. George Bull (Harmondsworth: Penguin, 1971), 36–7.

'An...corpse.' Johan Huizinga, *The Waning of the Middle Ages* (London: Dover, 2009 [originally published 1919]), 140.

Chapter 3: The iconoclasts

'I...did': quoted by J. J. Scarrisbrick, *The Reformation and the English People* (Oxford: Basil Blackwell, 1984), 70.

'Weep, weep, O Walsingham...': Emrys Jones (ed.), *The New Oxford Book of Sixteenth Century Verse* (Oxford: Oxford University Press, 1991), 551; quoted by Felicity Heal, *Reformation in Britain and Ireland* (Oxford: Oxford University Press, 2003), 217.

'Our...overthrowne': quoted by Stanford E. Lehmberg, *The Reformation of Cathedrals: Cathedrals in English Society, 1485–1603* (Princeton, NJ: Princeton University Press, 1988), 117.

'certain...get': quoted by Joyce Youings, *The Dissolution of the Monasteries* (London: Allen and Unwin, 1971), 164.

Quotations from Foxe from *Foxe's Book of Martyrs: Select Narratives*, ed. John N. King (Oxford: Oxford University Press, 2009).

Chapter 4: The revenge of the dead

Ballads quoted from *English and Scottish Popular Ballads*, ed. Francis James Child, 5 vols (London: Sterns, Son, and Stiles, 1882–98).

Chapter 7: The sixties

'I waked one morning...': Horace Walpole to William Cole, 9 March 1765: *The Yale Edition of Horace Walpole's Correspondence*, ed. W. S. Lewis, 48 vols (Oxford: Oxford University Press, 1937–83).

Chapter 11: New England Goths

'bewilderingly...affirmation'. Leslie Fiedler, *Love and Death in the American Novel* (London: Paladin, 1970), 29.

'All...again': quoted by David Punter, *The Literature of Terror*, 2 vols (London: Longman 1980, 1996), vol. 2, p. 39.

'we...Hawthorne': quoted by Teresa A. Goddu, *Gothic America: Narrative, History, and Nation* (New York: Columbia University Press, 1997), 131.

'You...unacceptable': quoted by Goddu, 154.

William Faulkner, *Requiem for a Nun* (1951): 'The...past': quoted by Barack Obama in his speech on race during the 2008 presidential campaign (see, for example, http://www.post-gazette.com/pg/10204/1074661-153.stm).

Chapter 12: Goths at the movies

'the...mad': quoted by David Robinson, *Das Cabinet des Dr. Caligari*, BFI Film Classics (London: British Film Institute, 1997), 10.

'It...sources.' David Pirie, *A Heritage of Horror: The English Gothic Cinema 1946-1972* (London: Gordon Fraser, 1973), 48.

Chapter 13: First and last and always

'First...Always' is the title of the album and the opening track by The Sisters of Mercy, *First and Last and Always* (London: WEA, 1985).

'We bring...it': quoted by Thomas Elsaesser, 'No End to Nosferatu', in *Nosferatu* (1921), dir. F. W. Murnau, Masters of Cinema DVD (Eureka, 2007), 7–24, p. 21.

'The slashing...film': quoted by Shawn Rosenheim, *The Cryptographic Imagination: Secret Writings from Edgar Allen Poe to the Internet* (Baltimore: Johns Hopkins University Press, 1996), 96.

'Horror...horror.' Stephen King, *Danse Macabre* (London: Hodder, 1981), 250–1.

'characters...unease': quoted by Christopher Frayling, 'We Live in Gothic Times...', in *The Gothic Reader: A Critical Anthology*, ed. Martin Myrone (London: Tate Publishing, 2006), 12–20, p. 14.

'tired old necrophiliac': Malcolm McLaren in *The Great Rock 'n' Roll Swindle*, dir. Julien Temple (released 1980; Virgin Video, 1982).

Finally, there are occasional lines and phrases taken from my own published work.

Further reading

Introductions

Markman Ellis, *The History of Gothic Fiction* (Edinburgh: Edinburgh University Press, 2000).

Richard Davenport-Hines, *Gothic: 400 Years of Excess, Horror, Evil and Ruin* (London: Fourth Estate, 1998).

Jerrold E. Hogle (ed.), *The Cambridge Companion to Gothic Fiction* (Cambridge: Cambridge University Press, 2002).

David Punter (ed.), *A Companion to the Gothic* (Oxford: Blackwell, 2001).

David Punter, *The Literature of Terror*, 2 vols (London: Longman 1980, 1996).

The Goths in late antiquity

Walter Goffart, *The Narrators of Barbarian History (A.D. 550–800): Jordanes, Gregory of Tours, Bede, and Paul the Deacon* (Princeton, NJ: Princeton University Press, 1988).

Peter Heather, *The Goths* (Oxford: Blackwell, 1996).

A. H. Merrills, *History and Geography in Late Antiquity* (Cambridge: Cambridge University Press, 2005).

G. W. Trompf, *Early Christian Historiography: Narratives of Retributive Justice* (London: Continuum, 2000).

Mediaeval Gothic

Jonathan Alexander and Paul Binksi (eds.), *Age of Chivalry: Art in Plantagenet England, 1200–1400* (London: Weidenfeld & Nicolson, 1987).

Paul Binski, *Becket's Crown: Art and Imagination in Gothic England, 1170–1300* (New Haven: Yale University Press, 2004).

Jean Bony, *The English Decorated Style: Gothic Architecture Transformed 1250–1350* (Phaidon: Oxford, 1979).

Johan Huizinga, *The Waning of the Middle Ages: A Study of the Forms of Art, Life and Thought in France and the Netherlands in the Fourteenth and Fifteenth Centuries* (London: Edward Arnold, 1924).

Richard Marks and Paul Williamson (eds.), *Gothic: Art for England, 1440–1547* (London: V&A Publications, 2003).

Early modern religion and politics

Eamon Duffy, *The Stripping of the Altars: Traditional Religion in England, c.1400–c.1500* (New Haven: Yale University Press, 1992).

Christopher Highley and John N. King (eds.), *John Foxe and his World* (Aldershot: Ashgate, 2002).

Colin Kidd, *British Identities before Nationalism: Ethnicity and Nationhood in the Atlantic World, 1600–1800* (Cambridge: Cambridge University Press, 1999).

John N. King, *Foxe's Book of Martyrs and Early Modern Print Culture* (Cambridge: Cambridge University Press, 2006).

Samuel Kliger, *The Goths in England: A Study in Seventeenth and Eighteenth Century Thought* (Cambridge, MA: Harvard University Press, 1952).

David Loades (ed.), *John Foxe and the English Reformation* (Aldershot: Scolar Press, 1997).

Graham Parry, *The Trophies of Time: English Antiquarians of the Seventeenth Century* (Oxford: Oxford University Press, 2007).

J. G. A. Pocock, *The Ancient Constitution and the Feudal Law* (Cambridge: Cambridge University Press, 1987).

Early modern culture

David Atkinson, *The English Traditional Ballad: Theory, Method, and Practice* (Aldershot: Ashgate, 2002).

John D. Cox, *The Devil and the Sacred in English Drama, 1350–1642* (Cambridge: Cambridge University Press, 2000).

William E. Engel, *Death and Drama in Renaissance England: Shades of Memory* (Oxford: Oxford University Press, 2002).

Stephen Greenblatt, *Hamlet in Purgatory* (Princeton, NJ: Princeton University Press, 2001).

The Gothic

Michael Neill, *Issues of Death: Mortality and Identity in English Renaissance Tragedy* (Oxford: Clarendon Press, 1998).

Thomas Rist, *Revenge Tragedy and the Drama of Commemoration in Reforming England* (Aldershot: Ashgate, 2008).

Philip Schwyzer, *Archaeologies of English Renaissance Literature* (Oxford: Oxford University Press, 2007).

Linda Woodbridge, *English Revenge Drama: Money, Resistance, Equality* (Cambridge: Cambridge University Press, 2010).

Later literature

Chris Baldick, *In Frankenstein's Shadow: Myth, Monstrosity, and Nineteenth-Century Writing* (Oxford: Clarendon Press: 1987).

Clive Bloom, *Gothic Histories: The Taste for Terror, 1764 to the Present* (London: Continuum, 2010).

Jodey Castricano, *Cryptomimesis: The Gothic and Jacques Derrida's Ghost Writing* (Montreal: McGill University Press, 2001).

Leslie Fiedler, *Love and Death in the American Novel* (London: Paladin, 1970).

Christopher Frayling, *Vampyres: Lord Byron to Count Dracula* (London: Faber and Faber, 1991).

Ken Gelder, *Reading the Vampire* (London: Routledge, 1994).

Christine Gerrard, *The Patriot Opposition to Walpole: Politics, Poetry, and National Myth, 1725-1742* (Oxford: Clarendon Press, 1994).

Teresa A. Goddu, *Gothic America: Narrative, History, and Nation* (New York: Columbia University Press, 1997).

Maggie Kilgour, *The Rise of the Gothic Novel* (Abingdon: Routledge, 1995).

Joanne Parker (ed.), *The Harp and the Constitution* (Leiden: Brill, 2013).

Toni Morrison, *Playing in the Dark: Whiteness and the Literary Imagination* (Cambridge, MA: Harvard University Press, 1992).

Fiona Robertson, *Legitimate Histories: Scott, Gothic, and the Authorities of Fiction* (Oxford: Clarendon Press, 1994).

Later architecture

Chris Brooks, *The Gothic Revival* (London: Phaidon, 1999).

Tom Duggett, *Gothic Romanticism: Architecture, Politics, and Literary Form* (Houndmills: Palgrave Macmillan, 2010).

Rosemary Hill, *God's Architect: Pugin and the Building of Romantic Britain* (London: Allen Lane, 2007).

Michael J. Lewis, *The Gothic Revival* (London: Thames and Hudson, 2002).

Michael Charlesworth, *The Gothic Revival: Literary Sources and Documents*, 3 vols (Mountfield: Helm Information, 2002).

Rosemary Sweet, *Antiquaries: The Discovery of the Past in Eighteenth-Century Britain* (London: Hambledon and London, 2004).

Visual image

Paul Coates, *The Gorgon's Gaze: German Cinema, Expressionism, and the Image of Horror* (Cambridge: Cambridge University Press, 1991).

Christoph Grunenberg (ed.), *Gothic: Transmutations of Horror in Late Twentieth Century Art* (Cambridge, MA: MIT Press, 1997).

Matt Hills, *The Pleasure of Horror* (London: Continuum, 2005).

Peter Hutchings, *Hammer and Beyond: The British Horror Film* (Manchester: Manchester University Press, 1993).

Gilberto Perez, *The Material Ghost: Films and their Medium* (Baltimore, MD: Johns Hopkins University Press, 1998).

David Pirie, *A Heritage of Horror: The English Gothic Cinema 1946–1972* (London: Avon, 1973).

David Skal (ed.), *The Monster Show: A Cultural History of Horror* (London: Plexus, 1993).

Marina Warner, *Phantasmagoria: Spirit Visions, Metaphors, and Media into the Twenty-First Century* (Oxford: Oxford University Press, 2006).

Goth culture

Dunja Brill, *Goth Culture: Gender, Sexuality and Style* (Oxford: Berg, 2008).

Lauren M. E. Goodlad and Michael Bibby (eds.), *Goth: Undead Subculture* (Durham: Duke University Press, 2007).

Mark Edmundson, *Nightmare on Main Street: Angels, Sadomasochism, and the Culture of Gothic* (Cambridge, MA: Harvard University Press, 1997).

Stephen King, *Danse Macabre* (London: Hodder, 1981).

Mick Mercer, *Gothic Rock* (Los Angeles: Cleopatra Records, 1993).

Natasha Scharf, *Worldwide Gothic: A Chronicle of a Tribe* (Church Stretton: Independent Music Press, 2011).

Carol Siegel, *Goth's Dark Empire* (Bloomington, IN: Indiana University Press, 2005).

Recommended music

Nick Cave and the Bad Seeds, *Murder Ballads* (London: Mute, 1996).

Daughters of Elvin, *Galdrbok: Medieval Songs of Love and Enchantment* (n.p., n.d.).

Fields of the Nephilim, *Elizium* (Beggars Banquet, 1990).

The Sisters of Mercy, *Some Girls Wander by Mistake* (London: Merciful Release, 1992).

Further reading

Index

ENGLISH LITERATURE
A Very Short Introduction
Jonathan Bate

Sweeping across two millennia and every literary genre, acclaimed scholar and biographer Jonathan Bate provides a dazzling introduction to English Literature. The focus is wide, shifting from the birth of the novel and the brilliance of English comedy to the deep Englishness of landscape poetry and the ethnic diversity of Britain's Nobel literature laureates. It goes on to provide a more in-depth analysis, with close readings from an extraordinary scene in King Lear to a war poem by Carol Ann Duffy, and a series of striking examples of how literary texts change as they are transmitted from writer to reader.

www.oup.com/vsi

ROMANTICISM
A Very Short Introduction
Michael Ferber

What is Romanticism? In this *Very Short Introduction*
Michael Ferber answers this by considering who the romantics
were and looks at what they had in common – their ideas, beliefs,
commitments, and tastes. He looks at the birth and growth
of Romanticism throughout Europe and the Americas, and
examines various types of Romantic literature, music, painting,
religion, and philosophy. Focusing on topics, Ferber looks at the
rising prestige of the poet; Romanticism as a religious trend;
Romantic philosophy and science; Romantic responses to the
French Revolution; and the condition of women. Using examples
and quotations he presents a clear insight into this very diverse
movement.

www.oup.com/vsi

WITCHCRAFT
A Very Short Introduction
Malcolm Gaskill

Witchcraft is a subject that fascinates us all, and everyone knows what a witch is - or do they? From childhood most of us develop a sense of the mysterious, malign person, usually an old woman. Historically, too, we recognize witch-hunting as a feature of pre-modern societies. But why do witches still feature so heavily in our cultures and consciousness? From Halloween to superstitions, and literary references such as Faust and even Harry Potter, witches still feature heavily in our society. In this Very Short Introduction Malcolm Gaskill challenges all of this, and argues that what we think we know is, in fact, wrong.

'Each chapter in this small but perfectly-formed book could be the jumping-off point for a year's stimulating reading. Buy it now.'

Fortean Times

ONLINE CATALOGUE
A Very Short Introduction

Our online catalogue is designed to make it easy to find your ideal Very Short Introduction. View the entire collection by subject area, watch author videos, read sample chapters, and download reading guides.

http://fds.oup.com/www.oup.co.uk/general/vsi/index.html

SOCIAL MEDIA
Very Short Introduction

Join our community

www.oup.com/vsi

- Join us online at the official Very Short Introductions **Facebook** page.
- Access the thoughts and musings of our authors with our online **blog**.
- Sign up for our monthly **e-newsletter** to receive information on all new titles publishing that month.
- Browse the full range of Very Short Introductions online.
- Read **extracts** from the Introductions for free.
- Visit our library of **Reading Guides**. These guides, written by our expert authors will help you to question again, why you think what you think.
- If you are a teacher or lecturer you can order inspection copies quickly and simply via our website.